IMAGES
*of America*

# NORTH AURORA
## 1834–1940

IMAGES
*of America*

# NORTH AURORA
## 1834–1940

Jim and Wynette Edwards

ARCADIA
PUBLISHING

Published by Arcadia Publishing
Charleston SC, Chicago IL, Portsmouth NH, San Francisco CA

Printed in the United States of America

Library of Congress Catalog Card Number: 2006930968

For all general information contact Arcadia Publishing at:
Telephone 843-853-2070
Fax 843-853-0044
E-mail sales@arcadiapublishing.com
For customer service and orders:
Toll-Free 1-888-313-2665

Visit us on the Internet at www.arcadiapublishing.com

# CONTENTS

Acknowledgments                                        6

Introduction                                           7

1.    Early Settlement                                 9

2.    Families                                        25

3.    Industry                                        47

4.    Fun Time                                        71

5.    School Days                                     93

6.    Architecture                                   109

Index                                                126

# ACKNOWLEDGMENTS

There are many, many people to thank for their help in writing this book. Without the kind permission of the Messenger Public Library to use the photographs collected by Emeline Messenger and Dorothy Yehnert, this book's first chapter would be noticeably less complete. Messenger also was the author of an early paper on the history of North Aurora. Stacy McReynolds, who had been researching her own house, caught the bug to form a historical society in town. She approached the mayor, John Hanson, and trustees Dale Berman, Mark Gaffino, Max Herwig, Mike Herlihy, Linda Mitchell, and Paul Shoemaker who encouraged her to proceed. When we met with the North Aurora Village Board in late 2005, some of the board members doubted that there was enough "stuff" out there for a real book on the village. "If we cannot find enough good pictorial material out there, we certainly are not going to be interested in writing the book," the council was told. What we found was not only enough material, but too much material to cover in one volume. It was then that we decided to end this study with 1940 and if there is enough interest, follow with a second book covering the time 1941 to the present.

The various pictures and diaries of early village families such as the Schneiders and Slakers were the backbone of the book. By February 2006 we had received volumes of information. The various family members who brought materials in to be copied or donated to a future society had as much fun as we did talking about the old days, connecting with old acquaintances, and sharing pictures of people from North Aurora's past. We even scheduled a meeting at a local restaurant to collect even more stories and material. We wish to thank all who saved their photographs and written materials from times past and shared them with us.

Those who shared information in weekly meetings at the Messinger Library included Joy Sandell Rogerson, Bob and Carol Frieders, Betty Slaker Tuftee, Barbara Messenger Tinker, Shirley Kokas Paxton, Rose Harding, Don and Ann Hosler, Bob and Dianne Smith, Mike and Debbie Glock, Don and Jenny Moutray, Marnie Pritchard, Bill and Linda Slaker, Ellen Shazer, Steve Miller, Rose Schwartz, Rick Feltes, Dave Sperry, Max and Billy Mignin, Al Broholm, Bob Yehnert, Don Voss, Mark Ruby, Maggie Bowers, Jan Rippinger, and Stacy McReynolds.

Particular thanks goes to Stacy McReynolds, Bob and Carol Frieders, Joy Sandell Rogerson, and Betty Slaker Tuftee who reviewed our work and edited the copy.

Others whose research we used or who helped included Waite and Frank Joslyn, Fred B. Graham Jr., Emeline Messenger, Clifford Illyes, A. G. Thurston, Irene McClennon, Linda Ott, Shelly Svendsen, Kathy Tinker, Angela Fornelli, Betty Hettinger, Betty Tuftee, David Scholes, Maureen Hola, Theresa Salazar, and Joanne Manning.

# INTRODUCTION

How does one go about evaluating and finding the perfect place to live? Magazines and newspapers are forever coming up with a list of the "Ten Best." These articles go to great length to note the deciding factors in choosing their picks. They typically mention climate, cultural offerings, medical and educational centers, libraries, and a host of other factors for their choices.

What they rarely investigate is the community's interest in preservation of the past, whether it be old theaters, businesses, or homes. It is great that North Aurorans pride themself on the hard copy records of its past, such as diaries and photographs and thousands of other artifacts and ephemera.

Whose job is it to find and share these records with the present day people living in the community? It is that of a historical society. In many parts of the country the collections from the past are deposited in a state or county level. More popular and close to the people are local town historical societies. Currently North Aurora does not have an historical society but is working towards forming one. Historical societies are treasure troves of information, which is often used to write articles and books about the community. We are happy to be a part of this organizational process.

The job of writing this story of North Aurora employed more of our sleuthing skills than usual because there was not a central research center we could use to find material. The upside of all this additional work was the delightful experience of contacting dozens of the people of North Aurora directly and sharing with them their stories and records of the past. A great bounty poured forth from these people, helping make *North Aurora* a most remarkable local history and a fine, exciting read.

The past of North Aurora is still emerging, even as this book is undergoing a final proofreading. An unknown cemetery was found this summer (2006), on North Aurora's east side, that contains 20 bodies, one of which is Clark Smith, a Civil War veteran who was buried in an iron casket. The fate of these remains is in the hands of the Illinois Historic Preservation Agency.

# We're From North Aurora

By Walter Hanosh and Fred Sandall

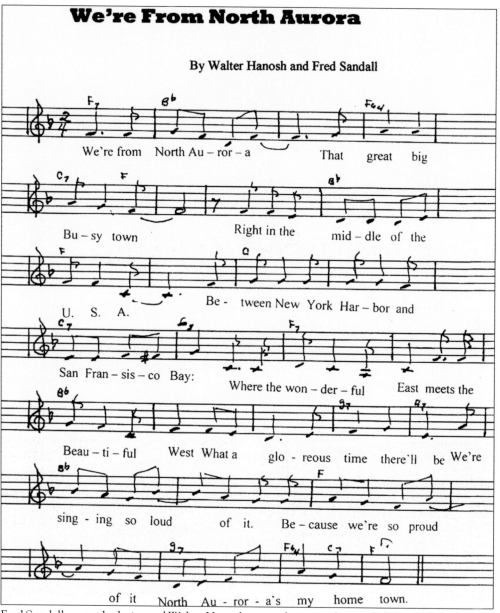

We're from North Au – ror – a     That     great     big

Bu – sy town          Right in the     mid – dle of the

Be – tween New York Har – bor and

San Fran – sis – co Bay:     Where the won – der – ful     East meets the

Beau – ti – ful     West What a     glo – reous time there'll be We're

sing – ing so loud     of it.     Be – cause we're so proud

of it     North Au – ror – a's     my     home     town.

Fred Sandell wrote the lyrics and Walter Hanosh wrote the music for "We're From North Aurora." It was sung at several North Aurora Days picnics and preformed by the household band.

# One

# EARLY SETTLEMENT

The first whites to become interested in the lands of Illinois were English and French trapper and traders in the 1700s. American Indian relations were peaceful, but in the early 1800s lead was discovered in what is now Galena. By 1847, eighty percent of the country's lead came from this area, and soon was mined out. The Black Hawk War of 1832 opened the door for farmers and others who wanted to settle in Northern Illinois. The Sauk leader Black Hawk organized many of the tribes in Illinois to fight for their lands against the farmers. Black Hawk lost the war, and by the end of 1834, most American Indians along the Fox River began to cede their lands and were forced to leave the state. Fertile prairie lands and waterways beckoned immigrants to the area. Among those were the Schneider brothers, one of whom was a millwright. On their way to settle along the Fox River, they inspected a small town to the east at the mouth of the Chicago River. They decided that the land was too swampy, and in 1834 chose a site on the Fox River. Thus was born North Aurora.

The ruling tribe of the area in 1834 was the Potawatomi under Chief Waubonsie who could assemble a war party of 500 warriors in a matter of a few hours. These Native Americans and nearby tribes led by Shabonna were peaceful and would warn the whites when hostile tribes went on the war party. In 1835, the tribe was removed to western lands.

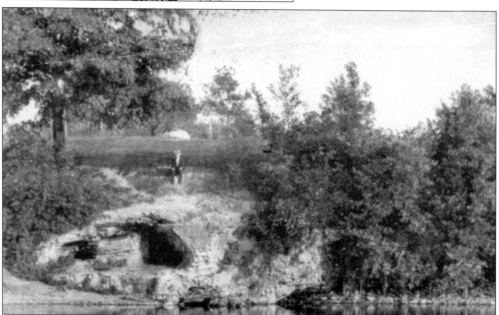

When whites began to settle in the North Aurora area, they took many place names from the Native Americans. There were also many tales that the settlers took to heart such as the legend of "Devil's Cave" along the Fox River. A "luminous spirit" was trapped in the cave and the entrance set on fire. A fiery figure, really a banished brave, came out of the cave, jumped into the river and drowned.

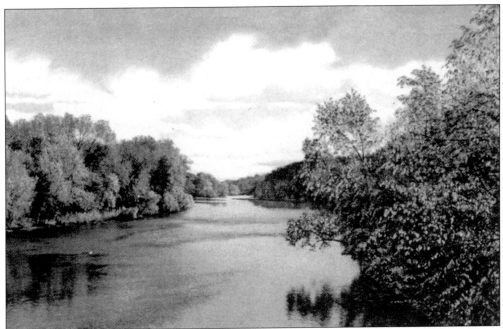

These Native Americans that lived in the North Aurora area fished the river and hunted deer, fox, wolves, and other small animals of the woods. Birds also were a source of food as well as nuts and berries. They harvested their fields of corn near the river and set beaver traps. They almost never went hungry living in harmony with nature.

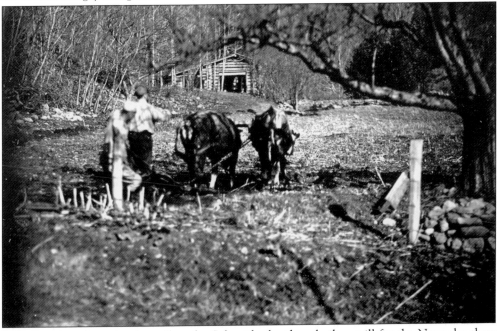

Before settling down in the valley, the Schneider brothers built a mill for the Naper brothers John and Joseph in what is now Naperville. They then cleared some land to farm wheat and corn and to build a small cabin. They were the first Germans in what was to become Kane County. However, John Peter Schneider was not only a farmer.

No. Aurora, Ill. Dam and Falls.

John Peter Schneider's expertise was building mills. The island in the Fox River was the perfect site for a millrace and sawmill. The Schneiders built a dam across the river of rocks and tree stumps to harness waterpower. Mail was delivered to the mill and addressed to Schneider's Mill. Walnut, oak, ash, maple, and pine boards cut from the "Big Woods" flowed out of the sawmill. A much-later dam is shown in this c. 1900 postcard.

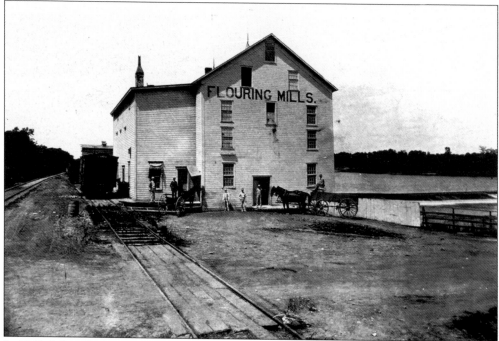

In 1860, Schneider built a gristmill on the west bank of the river to grind feed for the surrounding farmers' livestock. Two water runs made of stone soon grew to four. The mill could then produce 100 barrels of flour a day. This photograph shows the mill in 1895. The mill burned in 1919.

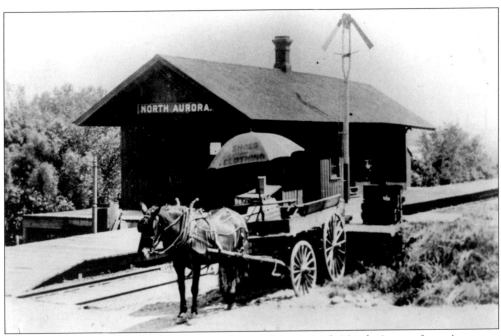

The Chicago and Aurora Railroad built a branch line through North Aurora from Aurora to Turner's Junction (West Chicago) in 1850, hauling freight and passengers and making industry possible. A branch of the Chicago and Northwestern Railroad was also built from Geneva to Aurora for freight with a stop in North Aurora. This photograph shows a depot building in 1910. American Express had its own wagon at the depot.

In 1850, families in town such as the Schneiders and the Ochsenschlagers (later shortened to Slaker) decided it was time to build a schoolhouse. The 30-by-30-foot building was constructed on the west side of the river. East side students boated across the river in warm weather and skated over when the river was frozen. In 1863, a large school was built further south, which was also used as a church. Attendees parked their fishing poles at the steps when meeting time arrived.

North Aurora industry was not restricted to flour and lumber mills. The Hartsburg and Hawksley mill began turning out wooden doors, trim, sash work, and other wooden products for houses in 1863. It was located at the present site of city hall. A millrace, and later turbines, drove the machinery located on the top floors. This almost free power source was used until the 1930s.

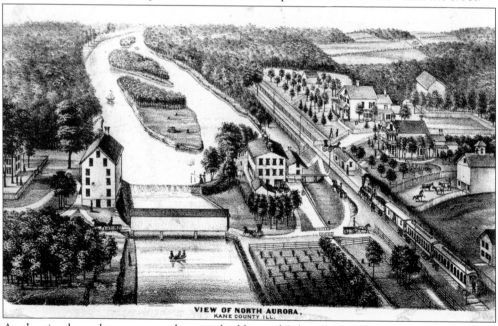

VIEW OF NORTH AURORA,
KANE COUNTY ILL.

As the simple settlement grew, the postal address of Schneider's Mill was changed to North Aurora. Traffic across the Fox River had increased so much by 1868 that the village bought a covered bridge from Aurora and moved it upriver to make travel easier for their citizens. This sketch of the village is an 1872 view.

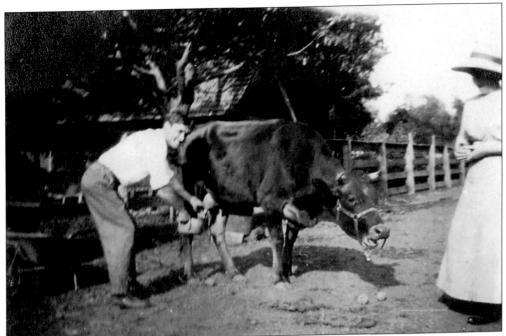

After the Civil War, local farmers went into the dairy business due to the huge demand for milk in Chicago. So many farmers began dairying that in the 1870s the farmers established the North Aurora Creamery Company. In the first year, 400,000 pounds of milk were processed. Much of the milk was used by a local cheese factory, which exported their products as far away as England.

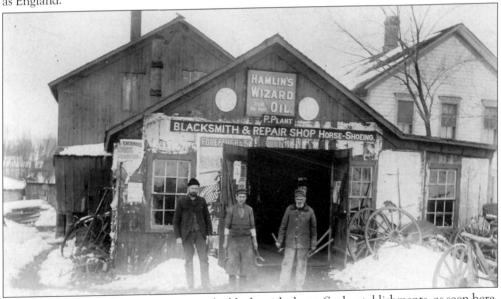

Perhaps the busiest places in town were the blacksmith shops. Such establishments, as seen here, employed men who could not only practice the craft of blacksmithing, shoeing all the local horses, but also could engage in wagon and carriage repair and make all kinds of custom iron work. Pictured here in 1905, from left to right, are Peter Petit, John Plante, and Peter Plante. Here business and living quarters seem to be one and the same.

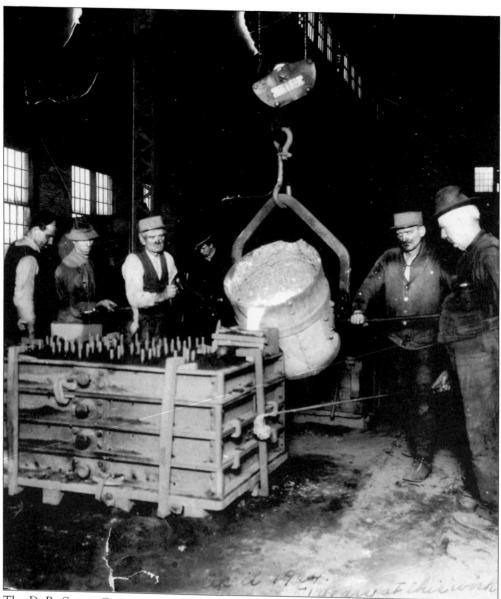

The D. R. Sperry Company expanded from Batavia to North Aurora in 1870 to manufacture hollow ironware and feed boilers. This 1924 photograph shows, from left to right, unknown, George Wennmacher, Lou Boardman, unknown, Fred Eichsmann, and James Kelleher watching the molten iron being poured from the ladle to the mold. Working in the foundry was dirty, dusty, and dangerous work. There were no safety shoes, dust masks, safety glasses, or hard hats. Another early manufacturer in North Aurora was the Aurora Smelting and Refining Company located beneath the bridge on the east side of the river. This plant was used for processing ore from western states separating gold, silver, lead, and other metals. In later years, the plant was taken over by the Aurora firm, Love Brothers, and the land surrounding the factory was called "Lovedale."

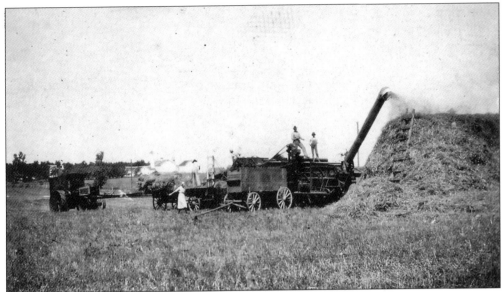

The demand to feed the nation's skyrocketing population in the later part of the 19th century increased settlement of the plains. Farmers turned from the use of the sickle (reaping hook) and cradle to reapers. The machinery was no longer made of wood with metal parts, but entirely made of metal. North Aurora foundries aided this new mechanized farming age. The Slakers are harvesting a fall crop in this photograph.

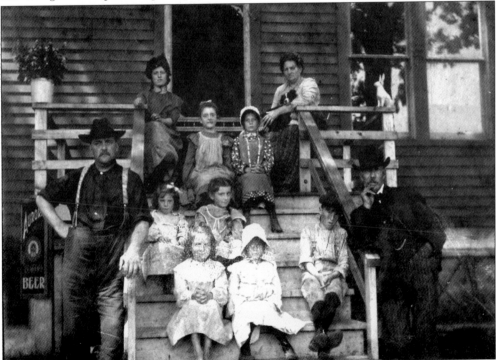

Shown here is a very early photograph of the North Aurora Hotel on the corner of Oak and Monroe Streets. This was the earliest hotel in North Aurora and the tavern was part of the establishment. The Crushorn brothers and their families are sitting for the photographer.

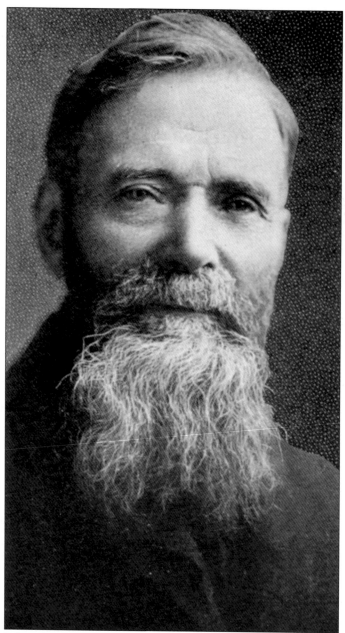

John Frederick Schneider was only six years old when his family settled in North Aurora. A little log cabin was built for a school on the Schneider property about 10 years later in 1844. This site served for many years to educate the children of neighbors several miles away from the farm. John F., aided by his jack-of-all-trades father, John Peter, built the mill in North Aurora in 1862. It is said that he inherited "an adventurous disposition" from his pioneering father. He went west in 1852 in search of gold. He and a friend traipsed across the prairie with a schooner drawn by one pair of oxen, two pairs of steers, and two pairs of cows. He remained on the Pacific coast for five years and made his way home in 1857 by way of the Isthmus of Panama and the city of New York. The gold fever was still in his blood, and in 1879, he went prospecting in South Dakota. He returned to his family and farming at the end of the year.

Charlotte Denham and her parents migrated from England and settled on a farm near the Schneiders. John Frederick married Charlotte in 1858. He kept day-by-day diaries, which are fascinating to read. Here are some excerpts from 1858, "July 16 bought a marriage license for myself and CD pd $1.25; November 7 went over the river and on till found myself at M.R. Denham found myself content with my lady love; November 8 made known to him (Denham) that I wanted his daughter which was cheerfully greeted by all; November 16 bought stove $23.00, bread pan 2.12, milk pail .75, candle stick .25, set of case knives 2.25 and wash dish 2.12, 1 table 3.63, 1 bed stead 3.63, 6 chairs 3.50, 1 rocker 2.50 and 1 looking glass .50." On November 17, he continued shopping for one pair of kid gloves, a set of dishes, a set of tea and tablespoons. "7:00 pm got married."

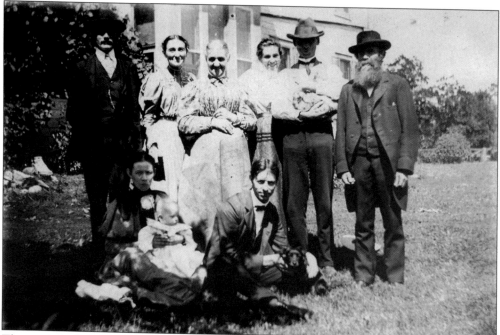

The second, third, and fourth generations of the Schneider family are shown here in front of their home (northeast corner of North Lincolnway and Oak Street) in 1902. The family would prosper and some of its members would become leaders in North Aurora for many years. From left to right are (first row) Eva Schneider Winter, holding Victor, and I. Edwin Schneider; (second row) Irving Winter, Emma Schneider, Charlotte Denham Schneider, Grace Holtz Schneider, George Schneider holding Emeline Schneider, and John Frederick Schneider.

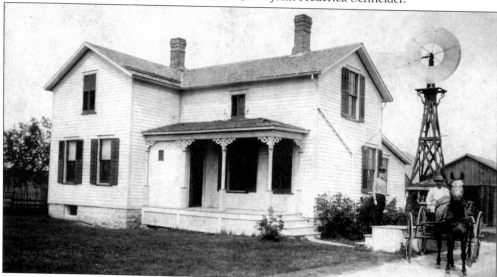

Three of John Frederick's children became schoolteachers. George W., the eldest son, bought a portion of his father's farm and was very much interested in horses and tinkering. He had many sheds for machinery, kept chickens on the property, and had a windmill installed as a source of power for the farm. This photograph shows the farmhouse with George in the buggy and his wife to the left. Note the front door area enclosed to keep out those cold winter winds.

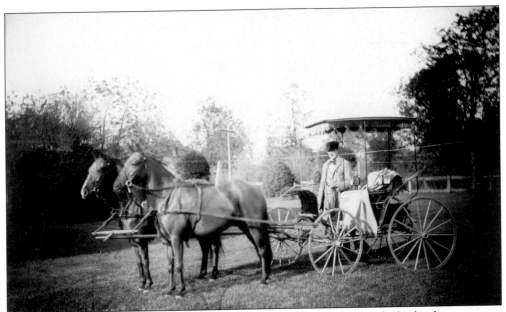

In the pre-automotive era of the 19th century, horses were used to work the land, as a way to get to town or visit a neighbor, and for a pastime running a race against a rival horse. George W. Schneider is shown here with his favorite matching pair of bays called Tom and Jerry. Such fabulous horses and the carriage show that the later generations of the family had moved into the upper class of Kane County society.

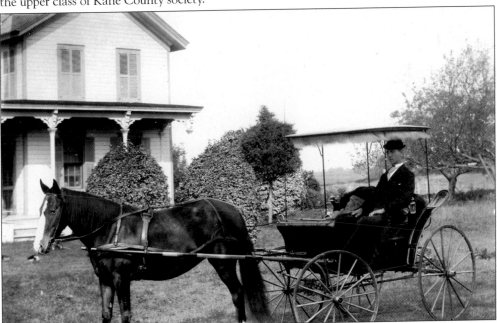

North Aurora and horses did not end with the Schneider family. Horseracing, as well as harness racing, would become key attractions in years to come. When the horses stopped racing, an abandoned hotel became the site for off-track betting in the late 1900s. Here is yet another Schneider, horse-lover I. Edwin, in front of his parent's house on the corner of Route 31 and Oak Street. How could girls resist this young man with such a swift conveyance?

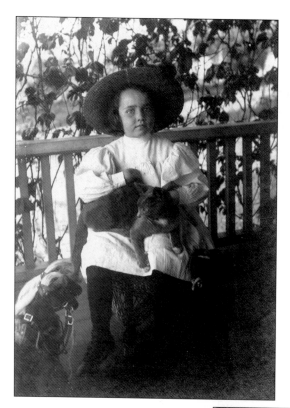

Farmer's children usually had favorite pets whether it be a pig, horse, or cat. Here we see Emeline Schneider with her special pet, a cat called Old Puss. Her parents were George and Grace Schneider. Much later she married and became Emeline Schneider Messinger. She saved the old North Aurora WPA Library in the 1940s from being closed. The current library carries her name.

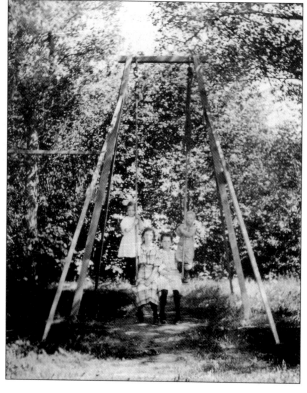

Rural American children had to make do with toys constructed of items easily found on the farm in the 1800s. Simple small figures carved from wood and corn-husk dolls were toys for boys and girls. Swings were great entertainment for all. Some swings were simple affairs attached to nearby trees or in this case a freestanding, large, homemade swing. Later in the century, iron toy fire engines and "real" dolls from Germany found their way into the homes of North Aurora families.

Music played an important part in the lives of the early German families, such as the Schneiders, in North Aurora and the nation. Instruments used in the home in the 1800s included the piano, parlor pump organ, and metal-works music boxes. To accompany singing, there were various automatic devices such as the Autoharp and the musicord, which is shown being played by two ladies. Later in North Aurora history, women would form their own "kitchen" band for novelty entertainment.

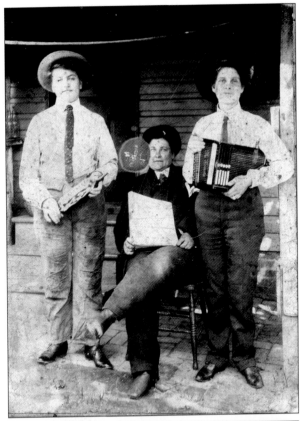

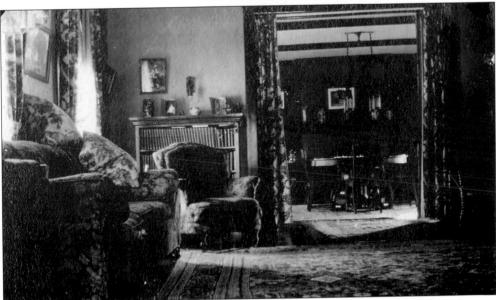

The first- and second-generation families of North Aurora were often large. Additional rooms were built off foursquare farmhouses to accommodate them. As families grew more prosperous, they decorated their homes with fancy carpets, draperies, and all kinds of Victorian clutter. When invited into the parlor, visitors could not fail to be impressed.

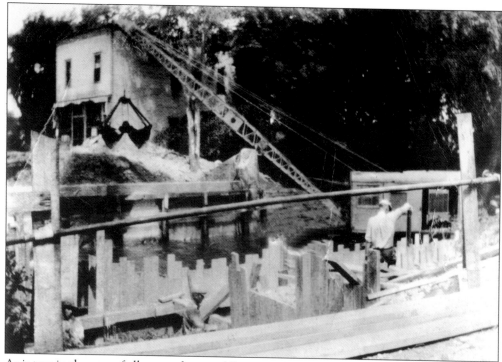

As is true in the case of all towns that straddle a river, North Aurora was constantly repairing or rebuilding its bridges. As commerce increased over the years, a simple wooden bridge would not stand the strain of heavy wagons and the weather. Finally a new, high-tech iron bridge replaced the old covered wooden bridge in 1887.

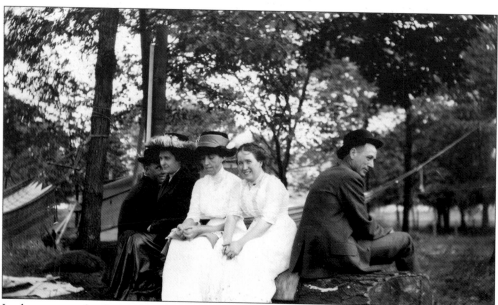

In the summer, families in North Aurora spend leisure time along the river with friends. Mame Kilian, Herman Kilian, and Jenny Slaker are three of those shown here "on a log: with an inviting hammock in the background." The unknown photographer is probably a Slaker.

# Two

# FAMILIES

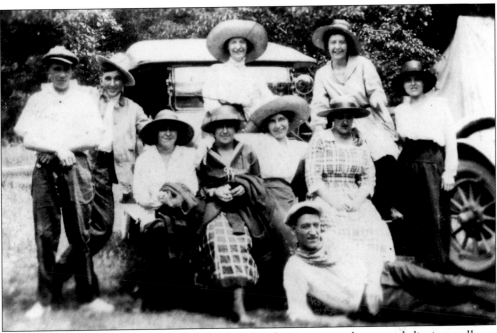

The early settlers of North Aurora helped each other in raising barns and digging wells on their 100 to 200 acre farms. Near the John Peter Schneider farm was one owned by Adam Ochsenschlager whose son John would remain on the farm when his father returned to live in Aurora. The North Aurora branch of the family would later change their name to Slaker. Homes sprang up to the east and to the west of present day Lincolnway and were occupied by the Hawksley, Johnson, Kurns, Erickson, Glines, Flynn, Long, Stewart, and Daleiden families. The Massees had a small farm nearby where the former North Aurora School still stands. The Meyers, Hettingers, Blasages, Undesser, and Anderson families lived on Route 25. The families of John Plante, Peter Plante, Fred Frydendahl, as well as the Schirtz and Hanosh families lived down the hill on Grant Street. The Croushorns had a saloon in town on the corner of Oak and Monroe Street.

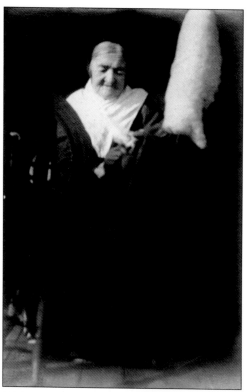

In the 17th and 18th centuries, the home was a factory where all sorts of products for daily life were made. Among other things, women made candles, soap, and butter. Spinning wheels, called Jennys, along with looms were used to produce thread and yarn necessary for making clothing for the family. Mary Slaker is here hard at work at her foot-powered spinning wheel.

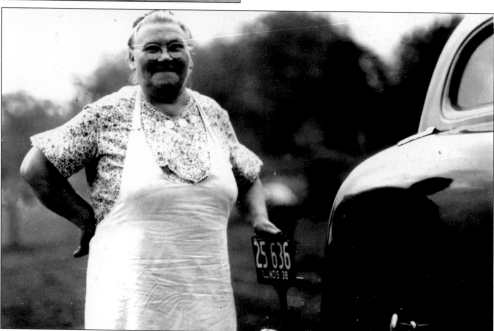

Grandma Flynn is shown here in front of a 1938 automobile during the last years of the Great Depression. Grandma is actually Maureen Nelson Fechner Flynn of the Flynn-Nelson family. She had nine children, which was not all that unusual in those days. Infant survival rates were improving by the 1930s, and most children survived to adulthood.

Another Grandma picture, this is Mary Slaker holding her grandson Ben who is wearing a christening gown. She is patiently rocking the baby to sleep. The flower wallpaper was probably green, which if so, had high arsenic content. Many a baby in the Victorian era died from handling or chewing such chemically treated wallpaper.

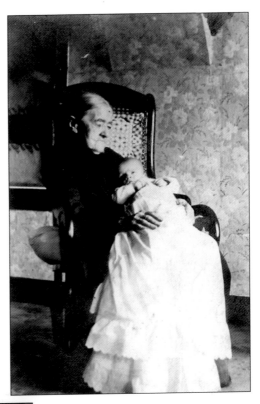

The Nelsons were another early family who lived in North Aurora. Here is a photograph of "Grandpa" Sven Aron Nelson who was born February 2, 1864, during the beginning of the Civil War, and died on July 19, 1921, at the age of 57.

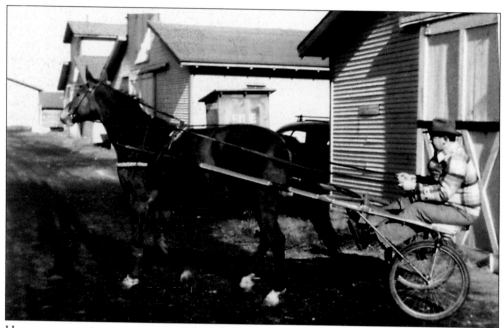

Horses were an important part of the life for early North Aurorans. At first they were used strictly for transportation to neighboring farms and towns. Fancy rigs and fast horses could be used to get the fun-loving farmer to church ahead of the others. After World War I, racing turned serious. Two-wheeled racing carts became popular and riders were called drivers. Here is a North Auroran out for a practice run.

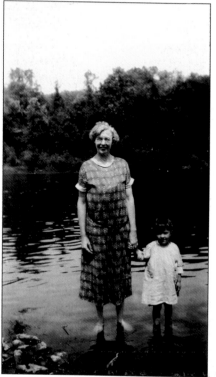

Cooling off in the Fox River was a relief in mid-summer. Mothers and their children waded and some spots in the river were still being used for swimming in 1926. Barb Daleiden Komes is shown to the left with Doris Frieders on the right. The Frank Komes lived on the east side of Lake Street (Lincolnway) near the North Aurora School, and John Komes lived on the west side of Lake Street.

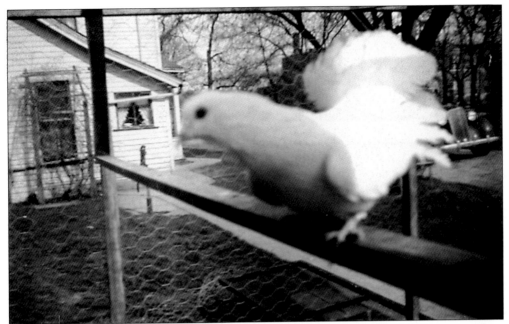

Racing horses were expensive, but racing pigeons were within the reach of the average village resident. It was a pastime for the adults and children in the family, and pet birds were treated as well as the family pig, cat, or dog. The most famous pigeon from the Aurora area was Gunpowder, a back-check homing pigeon who flew many secret messages for the army during World War I.

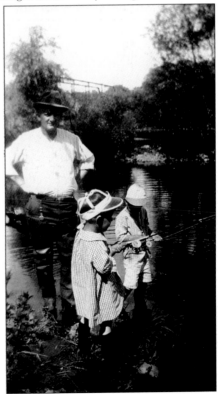

The North Aurora steel bridge looms in the background of this photograph. The bridge made it much easier to do business on both sides of the river. John (J. M.) Frieders is teaching the next generation of Frieders how to catch a fish in the 1920s.

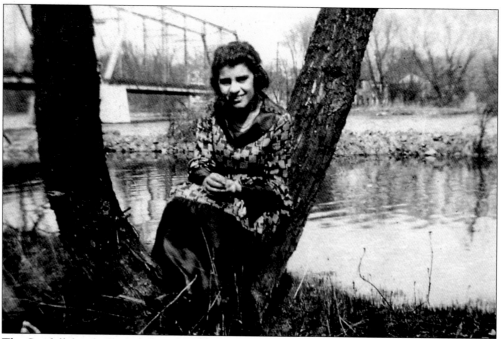

The Sandell family frequently visited Vera Croushorn because she was a close friend and lived just north of them on Monroe Street. Here she is in a new frock on the west bank of the Fox River south of the bridge. Notice the bridge in the background.

Old family photographs are not only invaluable remembrances for family members, but are also equally important in showing buildings that no longer exist in the village. The Frieders' collection of photographs shows baby "Bobbie" and behind him the west side of the store located on the site of the present fire station. Note also a farmer's silo in the distance.

Handmade swing rockers were popular outdoor fixtures in North Aurora. This swing was located on a pad west of an old store building and shows Grandpa Plum helping Doris Frieders climb up onto the platform between the two seats on the rocker.

Emeline Schneider had a pet goat named Bessie. She is shown here with Leo Schneider, age four. Emeline, 12 years old at the time, remembered years later that she was wearing a blue coat with gold buttons and a red hat. She appears worried that the goat might eat her buttons.

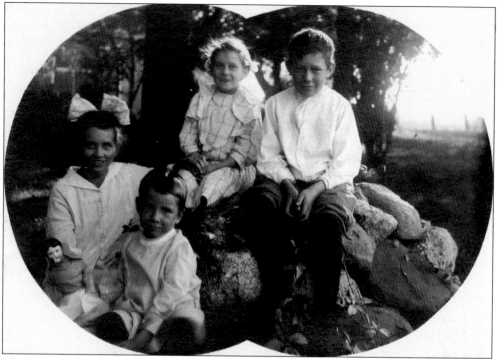

This spectacular postcard view of children is dated around 1913. This type of double circle format is most unusual and has the qualities of a studio photograph, but this picture was taken at the children's Aunt Caroline Angell's farm on Sullivan Road. Shown are Evelyn and Sidney Winter and Emeline and Leo Schneider.

During the depression years, children's toys were in abundance but were too expensive for many families. Bicycles and metal pedal cars fell into the category of luxury toys. Doris Frieders and her brother Bob are shown here with his new bike in the side yard of the family home.

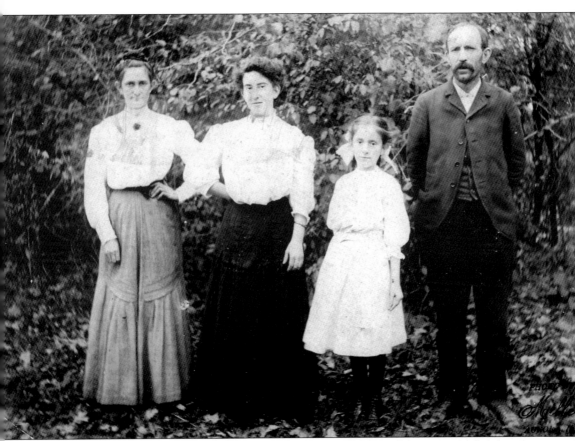

The Plum, Hopp, Frieders, and DeKing families in North Aurora all became one big, happy, extended family towards the end of the 19th century. In this large, cabinet-size photograph from left to right are Barbara Hopp Plum, Katherine Plum (DeKing), Anna Plum (Frieders), and Peter Plum. At this time men's jackets were cut quite differently. Notice that Peter's jacket has only the top button fastened, showing off the vest underneath. He also would have a watch in the pocket of that vest. Men did not wear wristwatches until the movie star Rudolph Valentino made them popular. Women wore their tiny watches on retractable chains on their blouses at this time.

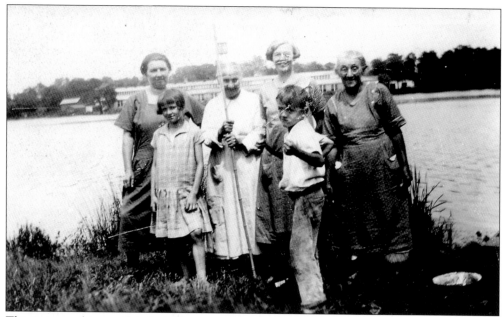

This is a rare photographic find. Here are three generations of the Frieders clan out in full force on the west bank of the River. The group is caught at a happy, clowning moment when the young Frieders is out to punch the photographer. The bonus is a partial look at the west bank of the old smelting works, later to be home to 48 Insulation Company.

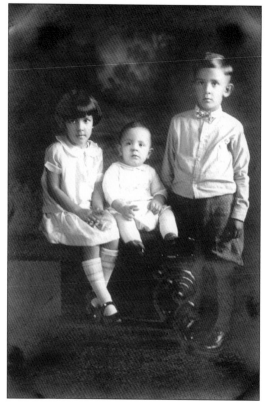

Early North Aurora babies appear to have been plump and happy, if this early Jensen photographer's studio photograph of 18-month-old Bob Frieders with his siblings Doris and John Jr. is typical of its time. All three children are staring intently on the same spot suggested by the cameraman.

North Aurorans were on the go constantly, up and down the Fox River shopping and selling in nearby towns such as Aurora and Geneva. They also caught the interurban railroad into Chicago and points beyond. Here Anna Plum and friend Ida appear to be taking off for parts unknown, perhaps to college.

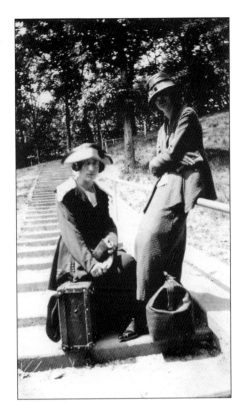

This early photographs shows Barbara Hopp Plum and Mary Sauber Frieders behind the family home on Lake Street. Life-long friendships were easier to maintain in the old days when most people lived and died within miles of their homes.

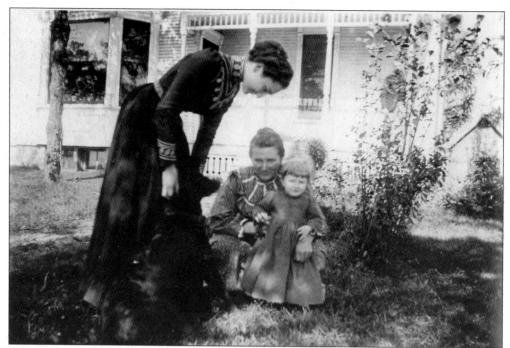

Young women of this era wore corsets to achieve that very small waist. This Slaker family photograph is captioned "Aunt Nora with blind Grandmother Slaker." The child is not identified. Corsets were easy to purchase with several corset factories in nearby Aurora.

The Barbers were also a prominent family in North Aurora. Two members of the family are shown here with friends in front of the family home. Pictured from left to right are Raymond Gray, Harriet Barber, Evelyn Barber, and Elmer Vaughn. Both girls are wearing fashionable cloche hats in this 1926 photograph.

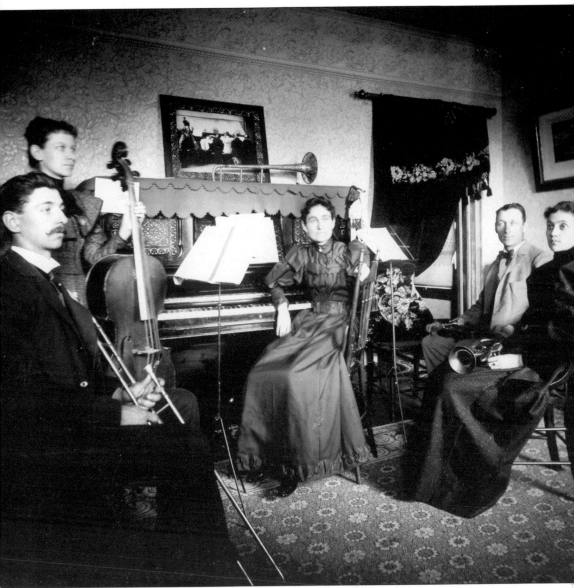

The Schneiders not only dabbled in fine horses, but they were also interested in the arts. They were sufficiently prosperous to afford music lessons and not only a piano but also other musical instruments so they could form their own "orchestra." In this rare interior photograph of the musical Schneiders from left to right are Edwin on trombone, Eva on bass, Emma at the piano, George W. on violin, and Nellie on cornet. There is an extra trombone on top of the piano. This photograph was probably taken at the family residence on Oak Street. Note the steam radiator, flowered wallpaper, and high ceilings, all typical of late-Victorian upper class homes.

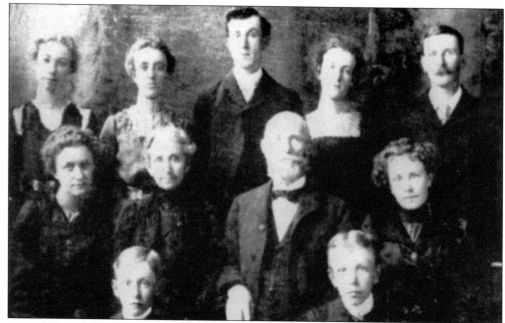

According to *Schneider's Mill*, this family view is of the William Hawksley clan. Hawksley was one of the early North Aurora businessmen. From left to right they are as follows: (first row) Harry and William, Jr.; (second row) Rosa Hawksley Chassell, Eliza, William Sr., and Bertha Hawksley Warne; (third row) Jessie, Annie, George, Mabel Hawksley Cromer, and Thomas. One daughter, Susan, died in infancy.

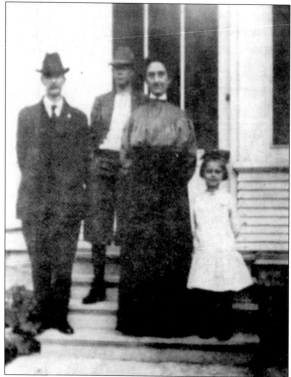

This later picture of Thomas Hawksley and his family is in front of their house. Behind Thomas and his wife Julia Burggraf Hawksley is their son Clarence. Daughter Dorothy Elizabeth is on the extreme right. Little girls seemed to always have a big bow in their hair in those days and short pants, such as Clarence is wearing, was the order of the day.

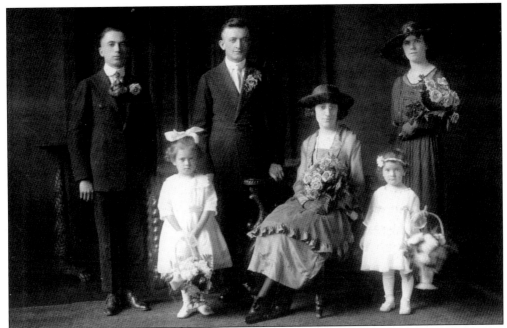

When professional photographers pose a group of participants in a wedding, it is taken for granted that the children will steal the show. Such is certainly true in this photograph showing the wedding party of John Frieders and Anna Plum. The young girl's motion that caused the blur actually adds to the attraction of the image.

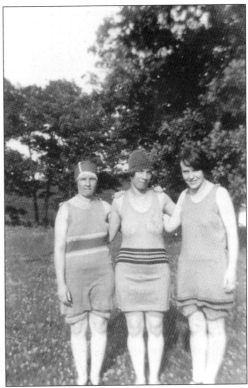

These are three local bathing beauties captured in all their glory along the banks of the Fox River in 1925. Bathing suits in the Roaring Twenties had scandalously been raised to show the knees. Nellie Wade, Margaret Wade, and Harriet Barber strike their best pose for the camera.

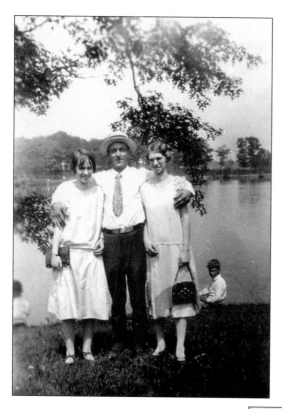

Evelyn Barber, Marilla Hines, and Fred Bouckup pose in their Sunday best on July 4, 1926, on the bank of the Fox River. Note the purses and low waisted dresses, proper dress for young ladies of the day. Straw hats were still a summer requirement for gentlemen in those days. Do you see the two young boys fishing in the background?

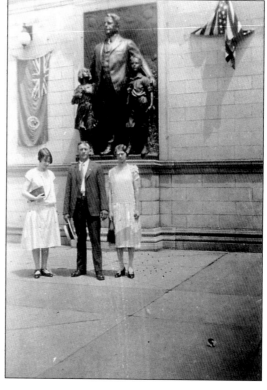

Mooseheart, the child city where the Fraternal Order of the Moose raised hundreds of orphaned boys and girls, was just north of North Aurora. It was a popular spot to visit on weekends. The young trio is standing in front of the memorial statue to children on the Mooseheart grounds.

40

The Barber family often went into Chicago to catch the sights. Lincoln Park was a popular destination as was taking an excursion trip on Lake Michigan aboard the *Eastlake*. Elmer Hines and J. C. Barber are shown here taking a stroll in Lincoln Park.

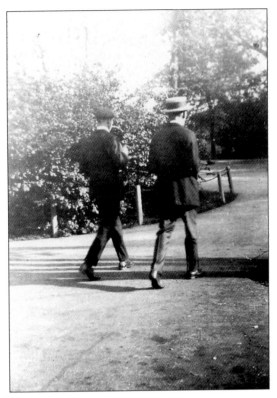

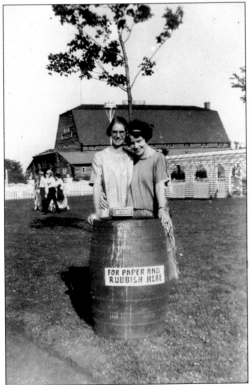

The Barber family and friends found excitement closer to home at Exposition Park in 1925. Harriet Barber, on the right, and Marilla Hines, on the left, decided to have their picture taken behind a garbage barrel with Lover's Lane and the famous Log Cabin Ballroom in the background.

On this 1926 excursion to Exposition Park, three ladies are waiting to take the trip down Lover's Lane—without male escorts to make things interesting. Evelyn Barber joins Harriet and Marilla in looking out an opening in the lane's trellised sides.

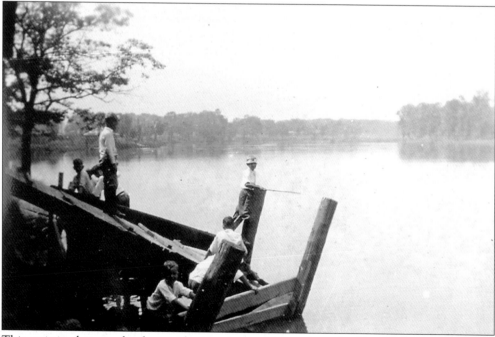

This artistic photograph of young boys and men fishing along the Fox River was part of the Barber scrapbook compiled in the 1920s. The banks of the river are canopied with tall trees, making the surrounding lands look deserted. In those days, fishing was more than just a pastime. Many a fish found its way to a dinner plate.

Also found in the scrapbook was this farm photograph showing a member of the family shooting a picture of the young man in the early, two-door automobile. Harriet Barber and a young child are shown on the left. Automobiles were the ticket to independence from parental control for the young people of North Aurora.

Mr. Barber and a young child sit on the back of a piece of huge farming equipment on the family farm. Besides cultivating the land, the Barbers had many high-tech ventilated chicken coops to house their flock and a small dairy. This was typical of farmers in the area at that time.

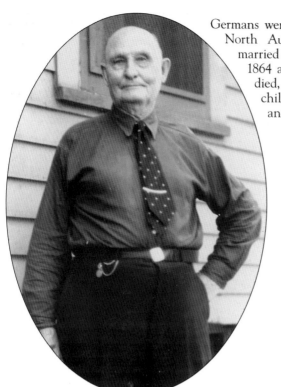

Germans were not the only people to settle in early North Aurora. Augusta Josefina Klingberg was married to Sven Aron Nelson, who was born in 1864 and died in Sweden in 1921. When Sven died, Augusta married William Flynn. The children of this marriage were Ida Van Fleet and Etta Gorham. William is pictured here.

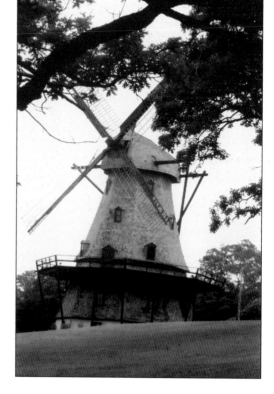

Grandma Flynn's side yard on Route 25 was like no other in North Aurora. It was a magical place. The expansive space included several ponds. One fishpond was shaped like the state of Illinois. Another was heart shaped. A six-foot high windmill, modeled after the famous Fabyan Windmill, was the centerpiece of the yard. Small houses and birdbaths completed the scenic back garden.

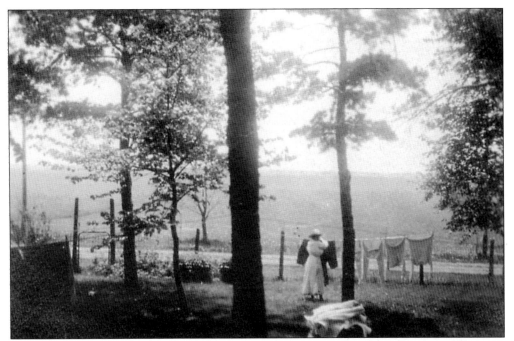

Laundry day is captured in this beautiful photograph that is worthy of an oil painting. Like some Monet canvases, Jennie Slaker is seen hanging out her laundry on a peaceful morning along the roadway in front of her house. Is there anything fresher than fresh-air dried laundry? Nowadays, it is illegal to dry laundry outdoors in many communities.

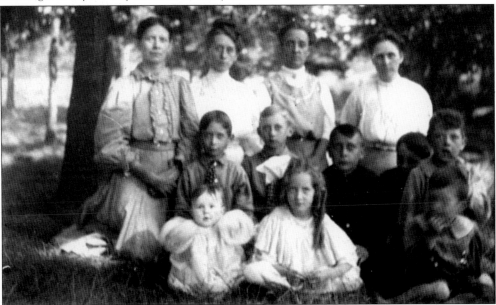

The Sidney Winter family was part of the Schneider family. This family is shown here picnicking near the Fox River in North Aurora. Children have a hard time sitting still for a photograph. The baby to the left is moving his arms up and down while the two boys on the right are still stuffing their mouths with food. This photograph was taken on October 22, 1917, only seven months after the United States entered World War I.

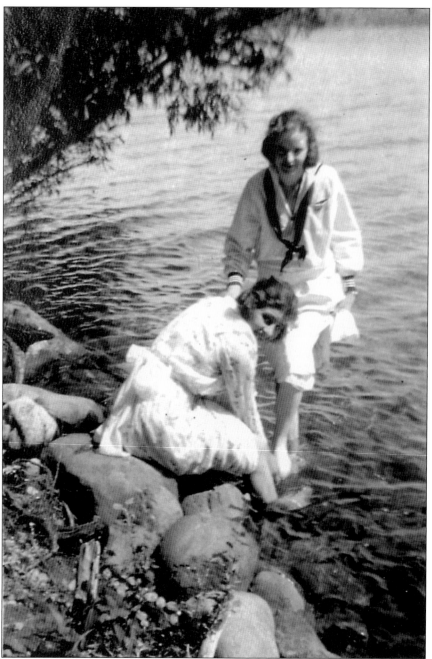

Although North Aurora did not have a great number of men serving in 20th century wars, the folks in town chipped in to help war efforts. Vera Swanson and a friend on the right with the sailor midi blouse were probably volunteers for one of the two North Aurora groups in the Red Cross during World War I. Emma Rheutasel was chairman of the North Aurora Community Workers, a group of 23 volunteers who wound surgical bandages, packaged gun wipes, and knitted sweaters for the Dough Boys "over there." One sweater consisted of 22,000 stitches, two hanks of yarn, and many hours of labor. Grace Schneider had her group of 25 working under another branch of the Red Cross, called the North Aurora Ladies Aid.

# *Three*

# INDUSTRY

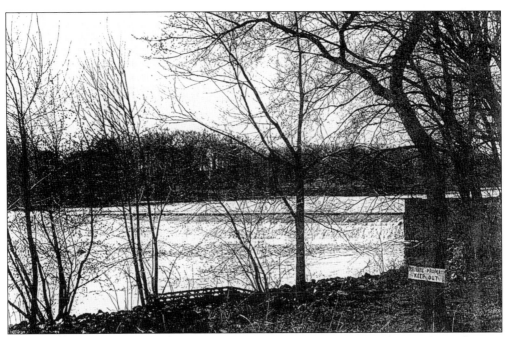

Betty Tuftee remembers, "Each season had its chores. Spring was planting time, haying, cultivating and housecleaning. Summer was thrashing. Fall brought plowing, corn husking, canning fruits and vegetables and housecleaning again. Winter was when the horse harnesses were repaired, machinery fixed and made ready for spring and building repairs made. At some time during the year when prices were right the cribbed corn had to be shelled. There was always something that needed to be done. All the manure that had collected from the animals had to be forked into the manure spreader and spread on the fields before plowing in the spring and fall." Such was the rhythm of life in the Fox Valley before industry began. Above is a view of the Fox River from the east side of North Aurora.

Horses were used on the farms to work in the field and for drawing wagons, buggies, and delivery trucks. Many southern blacks came north after the Civil War and found jobs as deliverymen. This unidentified man lived in North Aurora and did odd jobs for other residents.

## NORTH AURORA CREAMERY CO.
### Milk Contract.

This Agreement made this _____ day of _____ 1907 between the North Aurora Creamery Company, party of the first part, and each of the undersigned, parties of the second part.

WITNESSETH, that each of the parties of the second part, for himself and not for the others, for in consideration of the amounts hereinafter named to be paid to them, respectively by the party on the first part on the 23d day of each month following the month of delivery, hereby agrees to sell and deliver daily, to the party on the first part, on the platform of its factory at North Aurora, Ill., the number of pounds of good, pure milk produced from his or her individual dairy or dairies as specified below, to be delivered at such an hour as shall be specified by the party of the first part.

And does also agree that the milk of his or her cows shall be drawn in the most cleanly manner; and that the milk shall be properly strained and thoroughly cooled immediately after it is drawn, be frequently stirring the same until the animal heat is expelled and the temperature of said milk reduced to 60 degrees Fahrenheit and kept at that temperature until delivered at the platform of the North Aurora Creamery Company.

And does further agree that the cans in which this milk is delivered by the party of the second part shall be thoroughly washed and scalded and shall be brought to the creamery properly covered with canvas.

And does also agree that stables and sheds for keeping cows shall be thoroughly lighted and ventilated and white washed during the first two months of this contract.

And it is further agreed that should any member of the family or servant thereof be sick with any infectious disease to immediately notify the party of the first part during such contagion.

It is further agreed that if any serious interruption to the trade or to the manufacturer should occur which would interfere in any way with the party of the first part in manufacturing, handling or delivering or in obtaining the usual or necessary supplies for the same, or accident to the work of the Company occur to hinder the process of manufacturing, or if its usual facilities for transportation by any cause be interrupted, or if any restriction by legally constituted authority renders the carrying of the manufacturing impractical, then the said party of the first part shall immediately give notice if the fact and thereafter it shall be under no obligation to receive milk of the party of the second part under this contract during the period of such hinderance, interruption, strike, inability or restriction and until normal conditions are restored, but the parties to this contract agree that at the end of such period or periods and when normal conditions are restored that they and each of them are hereby bound to continue the performance of the contract as though such period or periods had not intervened.

It is also understood and agreed that the party of the second part agrees to make and deliver only goods pure, marketable milk of standard richness.

It is further agreed that the price paid per hundred pounds shall be in accordance with the average yield and that for every ten points above the average yield two cents per hundred pounds shall be added to the monthly price and for every ten points below the average yield two cents per hundred pounds shall be deducted from the monthly price.

Daily average to be delivered _____ pounds at _____ per 100 pounds for the month of _____ 190_

IN WITNESS THEREOF, the parties have hereunto interchangeably set their hands, the day and year above written.

A company was formed to build a creamery in 1873 where farmers could take their milk each morning to be processed either as drinking milk or as cheese. This company was in business until the 1920s. The property was sold to the North Aurora Elevator Company. Pictured is part of a milk contract used by the creamery in 1907.

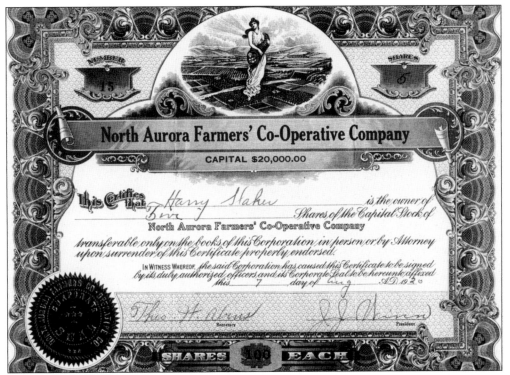

# North Aurora Farmers' Co-Operative Company

### CAPITAL $20,000.00

This Certifies that _Harry Slaker_ is the owner of _Five_ Shares of the Capital Stock of North Aurora Farmers' Co-Operative Company transferable only on the books of this Corporation in person or by Attorney upon surrender of this Certificate properly endorsed.

In Witness Whereof, the said Corporation has caused this Certificate to be signed by its duly authorized officers and its Corporate Seal to be hereunto affixed this _7_ day of _Aug_ A.D. 19_2_

Secretary          President

SHARES 100 EACH

Farmers have been coming together to form cooperatives for a very long time. John F. Schneider's diaries show that area farmers informally helped each other plow, plant and harvest in those early years. The North Aurora Farmers' Cooperative Company bought the North Aurora Creamery site and added a 120-foot grain elevator in 1923. The following year, the North Aurora Elevator Company took over the operation of the cooperative the following year.

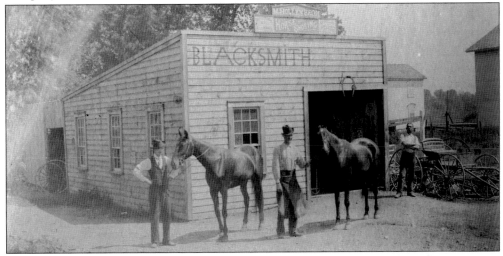

There once was a blacksmith on the west side near the creamery while Peter Plante's was on the east side on Grant Street. Replacing horseshoes was a brisk business since the iron shoes wore out or were lost. Blacksmiths also mended tools and machinery. Some were manufacturers of bicycles and cars. In her history of North Aurora, Emeline Messenger remembers, "Those blacksmith shops were interesting places with their glowing fires and bellows, but smelly."

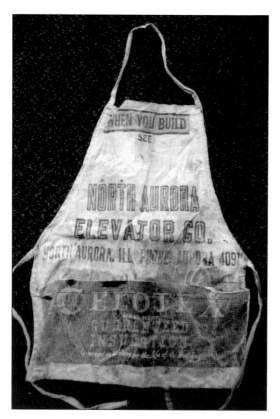

Once there was a good transportation network, manufacturers could sell their products nationwide. They needed a way to advertise to potential customers and brand names were born sometime in the late 1800s. This undated worker's apron advertising "Celotex" insulation was given to building supply stores. "When You Build, See" is followed by the special imprinted "North Aurora Elevator Co., North Aurora, Ill." Note the Aurora phone number 4091.

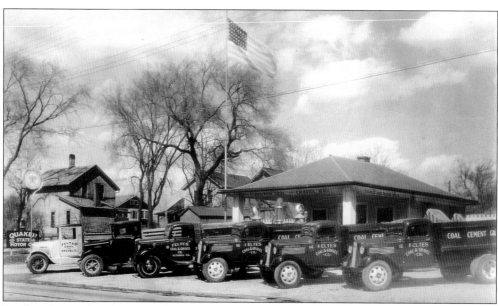

Brothers Leonard and Joseph Feltes began delivering coal before 1920 in horse-drawn carts. They were the first to have dump trucks in the Aurora/North Aurora area. They later mined sand and gravel on the east side of North Aurora and quarried stone. When the North Aurora pit was mined out, the company moved its operation to Elburn where it is still run by the Feltes family.

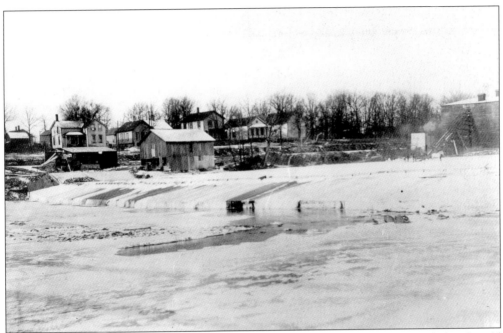

This historic photograph of Grant Street along the river in North Aurora includes the old icehouse where the ice was stored when it was harvested each winter. There it was stored in straw until it was distributed and used in the warmer, summer months. The houses in the background were part of Stone's Subdivision.

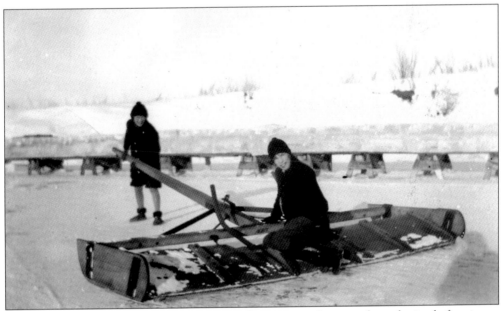

Wooden-framed snow scrapers were often used to remove the snow from the ice before it was scored and cut. A person in the business of cutting, storing, and selling ice usually used a horse-drawn device, however. These boys may be clearing an area to play hockey.

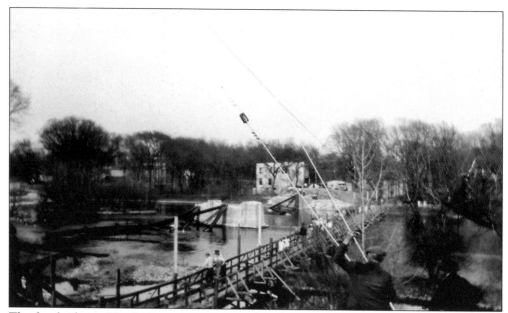

The first bridge in North Aurora was a covered bridge purchased from Aurora in 1868. Great hunks of ice piled up in the river and smashed into the bridge in the winter of 1887, carrying it away. This iron bridge was built to replace it on the original stone abutments and piles that had been quarried and hauled from Batavia for the old wooden bridge.

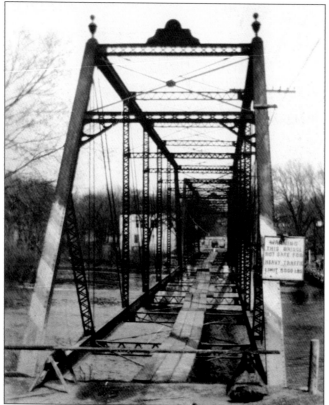

The iron bridge lasted until 1931 when it was declared unsafe for heavy loads. The bridge was dismantled and replaced by a steel-reinforced concrete bridge. One wonders how often people ventured to walk across those boards before the bridge was taken down.

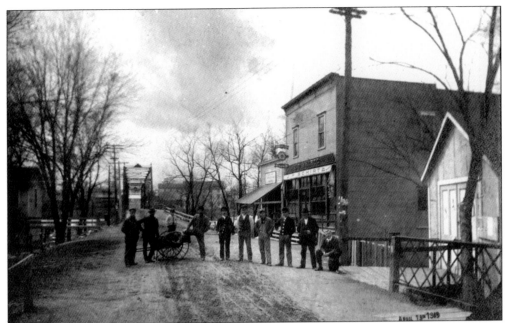

The 1909 city fathers are gathered on the main street of North Aurora, East State Street, for a portrait. Shown from left to right are Charles Howard, John Plante, Ted Plante (behind the wagon), unidentified, Peter Plum, unidentified, Ben Backes, unidentified, Charles Hagerman, and John P. Schirtz on the keg. The iron bridge is in the background, a grocery store, J. P. Schirtz's saloon, and a fire barn are on the right side.

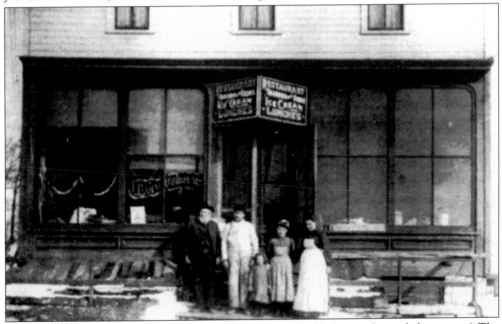

What good is a village unless there is a fine-dining establishment located downtown? The J. P. Croushorn family had a place that served blue-plate lunches and ice cream on the corner of State and Monroe Streets and a boarding house down the street at Oak and Monroe Streets. Standing in front of the restaurant is the Croushorn family.

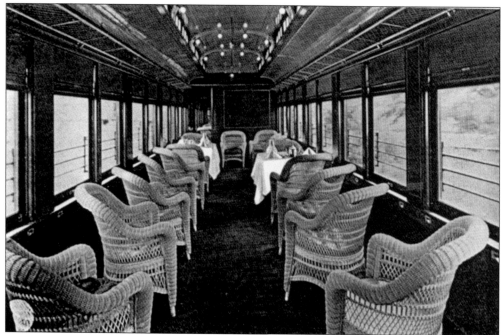

The interurban electric line, the Aurora, Elgin and Chicago Railroad, ran through North Aurora and provided easy access into Chicago. Pictured is the luxurious parlor and dining car, named "Carolyn," that one could ride into Chicago. The power plant for the system was located in Batavia.

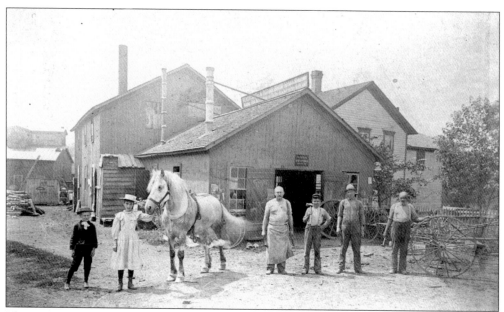

The 1893 workers at Plante Blacksmith are standing out in front of their shop on the corner of Grant and State Streets. Peter Plante, on the right, may have been repairing the wheel of the cart next to him. Note the smoke stacks on the left side of the building. They were extended above the roofline to prevent hot sparks from burning the roof. The Plante's lived in the house to the right.

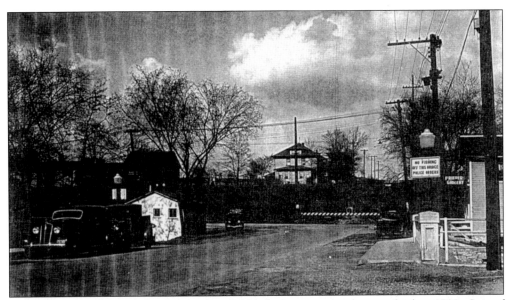

This photograph identified as "down-town" North Aurora was taken in the late 1930s. It is of East State Street just before going up the hill to Route 25. Frieders Grocery (its second location) is on the south side of State Street. Frieders' Island Inn was on the north side. The Frieders family emigrated from Luxembourg and arrived in the Fox Valley around 1850. This generation lived on the west side of the river on Lake Street (now Lincolnway).

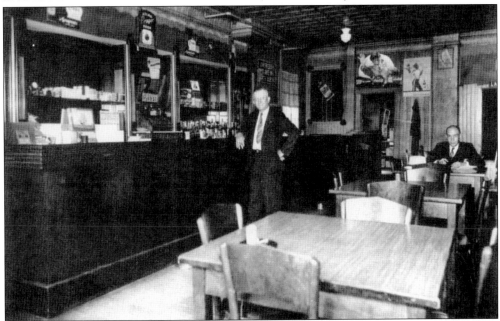

John M. Frieders is standing at the bar at Island Inn on State Street in North Aurora. This was a local saloon and family eatery. Gentlemen could stand at the bar, but ladies had to remain seated at the tables. Good food at reasonable prices was important to Frieders. Baked spareribs, Friday night fish fries, and the family's favorite barbecued beef sandwiches were all on the menu. The family is still using the barbecue recipe. The customer is unidentified. Note the tin ceiling, so prevalent in early stores.

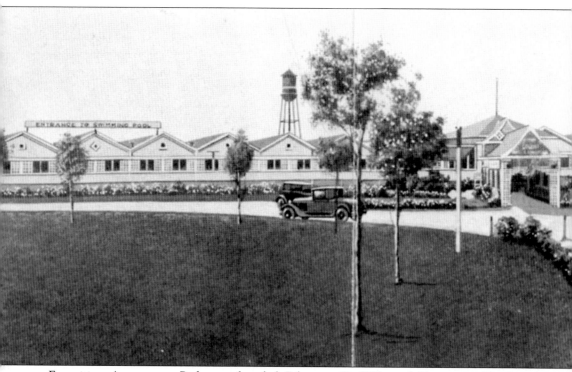

Exposition Amusement Park was founded February 17, 1922, and Exposition Hotel with 130 rooms was just inside the park. One could rent by the day, week, or month and enjoy the amenities of the park as part of the rent. Advertisements suggested, "Why not make it your summer home?" Use of the swimming pool and tennis courts and attendance at concerts was

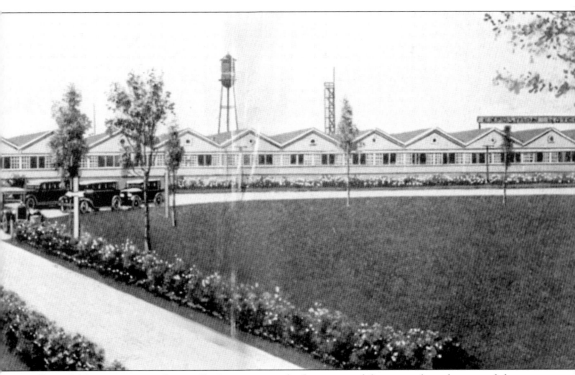

all available at no extra charge. Each apartment had a screened front porch and many of them overlooked the pool. Three dining rooms were maintained, and a grocery store was on the premises for those guests who wished to prepare their own meals in the kitchenettes that were included in each apartment.

People visiting the park expected to see their favorite attractions each year but also wanted new thrills. Frank Thielen, the visionary behind Exposition Park and Fair, hired the Thompson Brothers of North Aurora to take hot air balloons to the park where patrons would pay to go up in a tethered balloon. The Thompson Hot Air Balloon and Parachute Company operated in North Aurora until 1940.

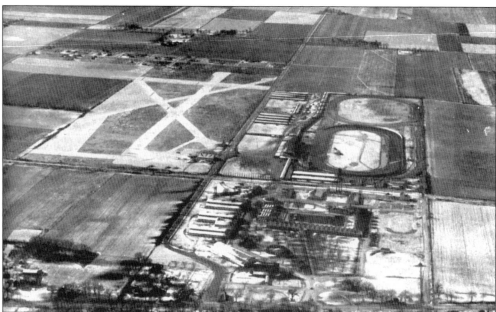

An airport was built in the 1920s right next to Exposition Park for those patrons who wanted to fly in to the park. Jonathan Livingston was the first manager and had a business based there where one could rent a plane or a pilot. Barnstorming was a popular attraction for park visitors. The City of Aurora bought the airport in the 1950s to provide a municipal airport for the city, but moved its operations to Sugar Grove when the toll way was built.

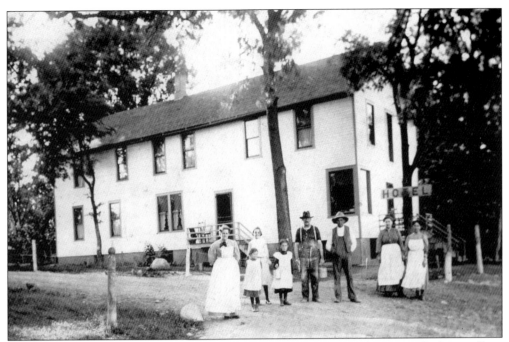

One of the businesses that seems to move the status of a community from a small, sleepy village to a bustling town is a hotel. A hotel means that outsiders are coming into town to transact business, enjoy a holiday, or make plans to open a store and settle in. This is a very early photograph of the North Aurora Hotel at the corner of Oak and Monroe Streets with the staff.

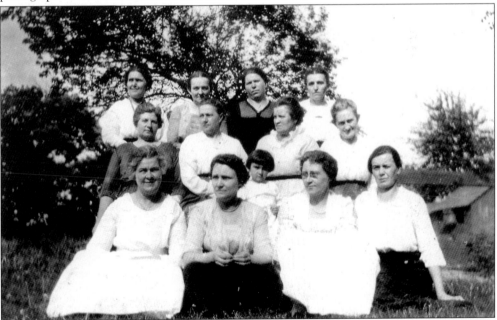

These unidentified women were members of the Royal Neighbors of America in North Aurora. These women came together to make a difference in their community and purchase life insurance. Royal Neighbors of America was one of the first organizations to offer life insurance for women. The national organization is still in existence.

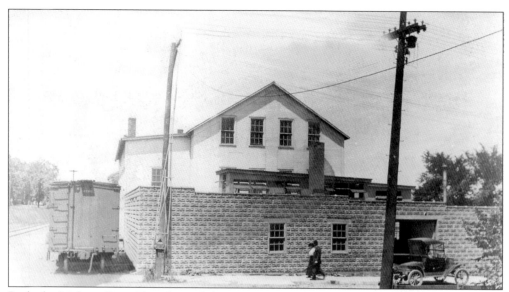

Both the Midwest Brass Foundry and the Aurora Smelting and Refining Company were close to rail sidings, but the foundry was on the west side of the river and the smelting and refining company was on the east side. Midwest Brass Foundry is pictured above. Note the rail line and Lake Street (Route 31) to the left. The photograph was taken in 1915, and the building was destroyed by fire in 1918. Historian Vernon Derry said that as early as the 1870s the Aurora Smelting and Refining Company purchased land and built a factory in North Aurora. At first the factory processed tin ore from Galena, Illinois. When the tin ran out, gold, silver, lead, and other metal ores were brought in for smelting. In 1893, gold was the main ore being processed. In 1890, at least 200 men were employed, and the output was 50,000 tons. The factory was purchased by the Love Brothers in the early 1900s, and at one time a suspension bridge served as an easy way for workers living on the west side of the river to get to work on the east side.

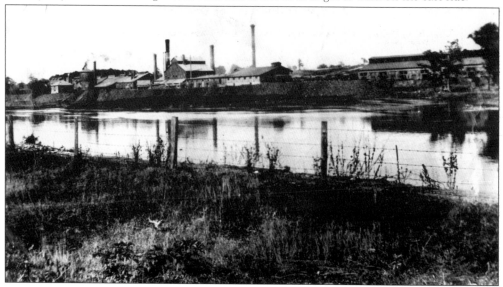

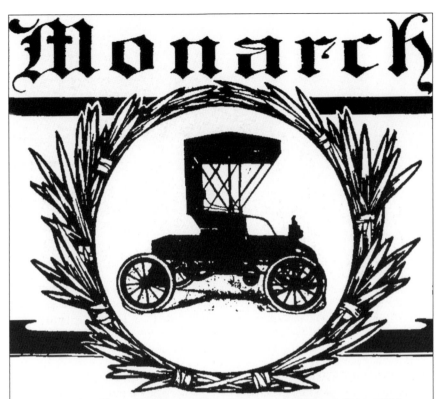

# Monarch

## 7 H. P. AIR-COOLED RUNABOUT

Simple, Easy Running        All Parts Accessible
Speed 4-22 Miles per Hour on High Speed Clutch
Body Rides on One Set of Springs, Machinery on Another
Planetary Transmission, Two Speeds Forward and One Reverse.
All Speeds Operated by One Lever.

### —AGENTS—

Joseph S. Heller. 1779 Broadway, New York City

D. L. Mulford, 514 N. Broad St., Philadelphia, Pa.

Auto Supply & Storage Co., 1416 Madison ve., Baltimore, Md.

Upton Funk, Shippensburg, Pa.

Fred K. Martin, Perth Amboy. N. J.

Ohio Pail Co., Middlefield, Ohio

Union Automobile Co., 4601 Olive St., St. Louis, Mo.

Carl W. Hays, Lexington, Mo.

Hayden Automobile Co., 1337 Michigan Ave., Chicago, Ill.

Gage Brothers, Lakefield, Minn.

A. W. Petersen, 320 W. 3rd Street, Davenport, Ia.

Moore Auto Co., Lincoln, Neb.

Geo. E Bartoo, 409 1st Ave., Spokane, Wash.

Price of Runabout, $500.00
Price of Runabout, with top, $50 extra.
Our Air-Cooled Engine is Absolutely Guaranteed.
Immediate Deliveries.

## Monarch Automobile Company, AURORA, ILL.

The *Aurora Beacon* pronounced North Aurora a suburb of Aurora in 1906. In talking about its businesses they wrote, "About a year ago the Monarch Auto Car Company started to build automobiles in North Aurora, prior to this time the company having been known as the Monarch Automobile Company. The company has a new model of automobile that is know as the Runabout, at the factory in North Aurora, the whole car is made. The new style car has met with the approval of many critics and experts on automobiles and the new style, it would seem, is destined to be a favorite with the auto enthusiasts." By 1908, the company had been moved to Aurora and the Runabout was no longer being made.

Here is the North Aurora intersection of State Street and Lincolnway around 1933 looking towards the bridge. The Congregational church is to the left of the gentleman, and Lambert Smith's Barber Shop and Frieders (first) Grocery Store are to the right. A small portion of the school building can be seen at the far left. The man is unidentified, but he may have worked at the service station located behind the photographer.

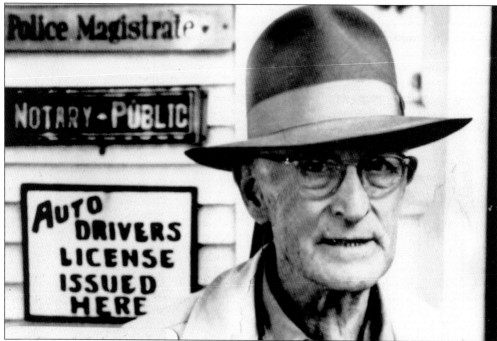

"The Man" in most small communities was the justice of the peace. North Aurora's most famous justice was George H. Gorham who seemed to have more jobs than Carter had liver pills. He would marry someone free of charge in two minutes flat and probably took only the same amount of time to notarize a document or issue a driver's license. In his spare time he was the station agent for the Northwestern Railroad in North Aurora.

# *HARTSBURG & HAWKSLEY CO.,*

MANUFACTURERS OF

## *Sash, Doors, Blinds, Brackets, Mouldings, Etc.*

ON THE C., B. & Q. AND C. & N. W. RAILROADS.

### North Aurora, Ill., *Feby 2-1900* 189

Sold to *Mr John F Schneider*

| | | | |
|---|---|---|---|
| 30 feet 2⅜ face ⅞ Ceiling Cypress | 1 | 35 | |
| 50 " ¾" Quarter round | | 25 | |
| 1 lb Nails | | 5 | 1.65 |

Rec'd Pay
Hartsbury & Hawksley Co

---

"In 1868 Alexander H. Stone purchased 101½ acres of land on the east side of the river in North Aurora from Richard M. Goodwin for $13,500, including the small sawmill and the east half of the dam. Alexander H. Stone and his brother, Andrew Jackson Stone built a mill on the east side of the island. In 1869 a company was formed consisting of the Stone brothers, Richard I. Smith, I. M. Tiffany, and Julius Brown. This company was named the North Aurora Sash, Door and Blind. They built another building across the millrace from the original building and purchased an interest in the waterpower. In 1879 William Hartsburg, William Hawksley, and Julius Brown formed a partnership and rented these woodworking buildings from Alonzo George who had acquired them during the intervening years. With a loan of $300 and a horse, they began operating the mill." This excerpt was taken from *Schneider's Mill.*

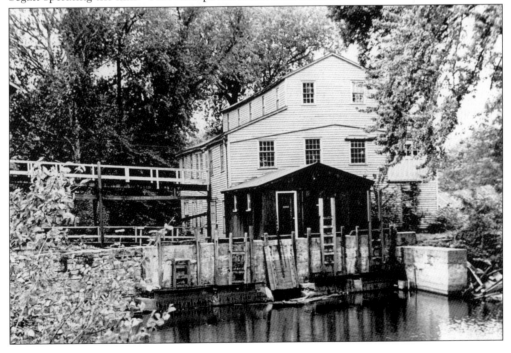

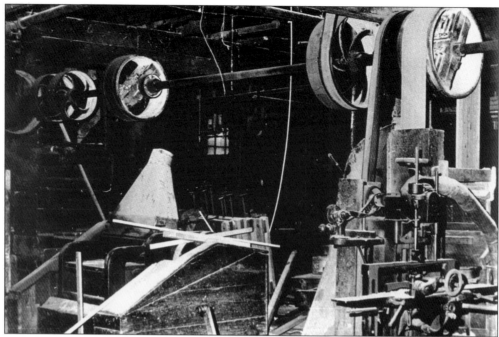

There were several floors to the factory. This floor had shafting at the ceiling level. This transferred power down to the machines on the floor with wide leather belting. By this time, shafting in factories was rounded, not four-sided as earlier shafting had been. The round shafting was also now made of steel instead of iron, which made it more reliable and less susceptible to shattering from stress.

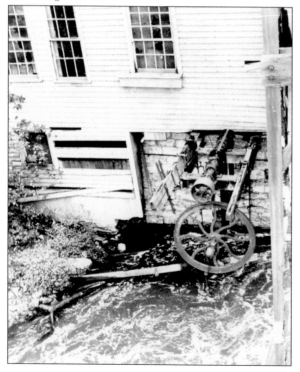

This old photograph of the Hartsburg and Hawksley works shows the inner workings of a classic water-powered factory. Note that the flywheel is still in place. What is missing is the wooden paddle wheel assembly that fit over the falling water, which turned the main shaft. A set of pulleys would transfer the power to machinery on all floors. The foundation of the building is native limestone.

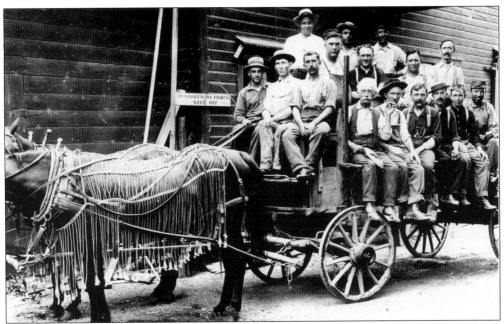

These are the men who worked at Hartsburg and Hawksley in 1914. The horse is wearing a fly swatter. Pictured from left to right are as follows: (on the seat) Nick Theis, Alfred Lundstrom, and Peter Kramer; (first row) William Long, Bob Flynn, Matt Schomer, George Worth, Charley Taske, and Joe Stewart; (second row) Jack Banbury, Mervin Angell, Herman Taske, and Henry Flynn; (third row) Otto Rieter, Gus Taske, and Fred Fredendahl.

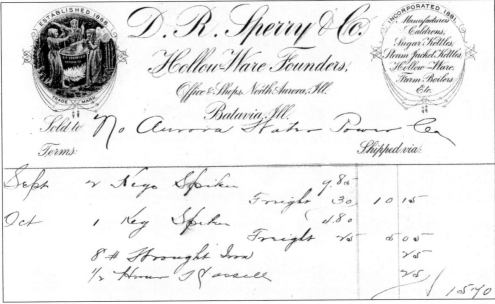

In 1933, Batavia historian Dorothy Ann Miller, interviewed David R. Sperry Sr. and wrote: "The filter press made by the D.R. Sperry Co. is in use not only in the home industry of the Campana Corporation, but by Proctor and Gamble, soap manufacturers, Eastman Kodak Co., the Dupont Corporation which manufactures rayon among other things, Fleischmann Yeast Co, the Elgin Watch Factory." The first Sperry patent was issued in 1890 for the shape of a filter press plate.

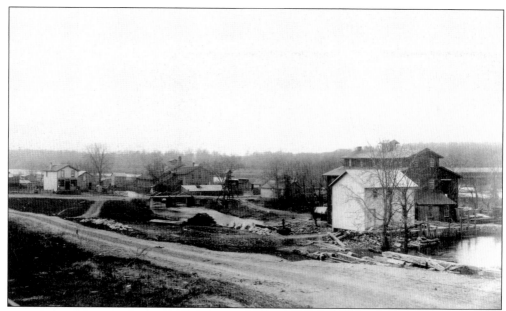

Here look southwest at the original Sperry foundry in North Aurora located on the island south of Route 56. As the water rotated the vertical shaft turbines, a pulley on the top would turn. A steel cable looped around the pulley, went to another pulley and turned it. The timber structure that looks like an old oil well is the cable transmission tower. The cable would run from the white building on the right to the tower to the foundry and back.

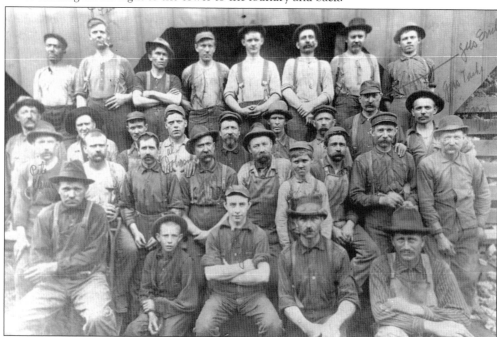

Dave Sperry, grandson of the founder and annotator of this group of foundry photographs, identified these men as possibly being from the machine shop based on the fact that they are relatively clean. Note that although none are old, two are young boys. Most of these workers were of either Swedish or German heritage. The workers called D. R. Sperry Company "the shop."

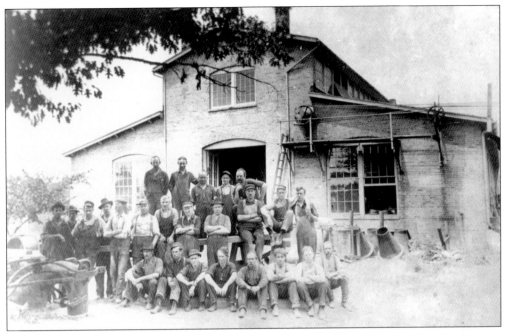

Here is another group of machine shop workers from a later period. Two pulleys can be seen going into the machine shop on the right side of the building. Water turbines at the dam drove them. The pulley shafts (jackshafts) went into the plant and ran the lathes and drill presses. Others went into the foundry section of the factory.

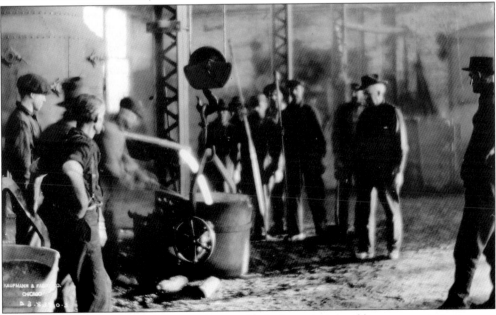

The riveted structure at the left was the cupola. In it a mixture of limestone, pig iron, scrap iron, and steel and coke (processed coal) was lit. A blower forced air into the bottom, making the coke burn so hot that it melted the iron (2,100 degrees Fahrenheit). When enough iron was melted, the molder "tapped" (opened) an outlet and the molten iron poured into the ladle. The ladle was then moved to the molds and the iron poured into them.

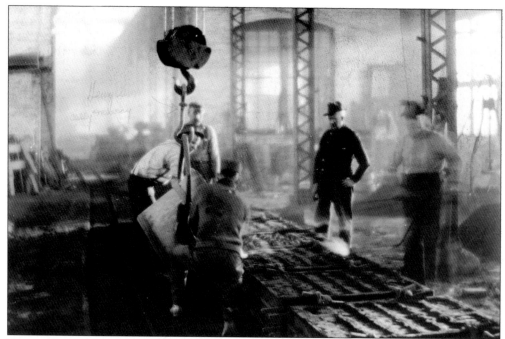

Two molders are pouring iron from the ladle into a mold to make a casting. Two of the molders were Cully Murray and Henry Plum. The others are unidentified. Jim Kelleher, shop superintendent, is watching with his hand on his hip. After the casting cooled, it was shaken out of the mold and put on small carts to be rolled to the sandblast room to be cleaned.

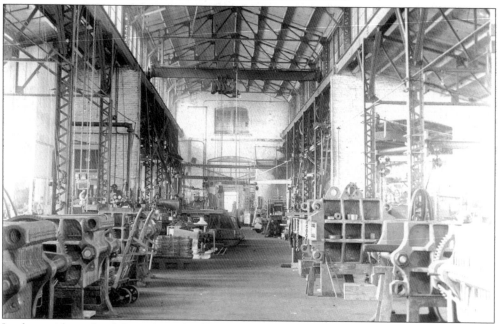

Look on either side of the aisle at the filter presses in various stages of construction. The small ones on the left were used to filter something very viscous, like raw nylon. The large one on the right appears to be a mash filter press used to make beer. At this time, sometime in the 1930s or 1940s, electricity, instead of water, was used to turn the pulleys.

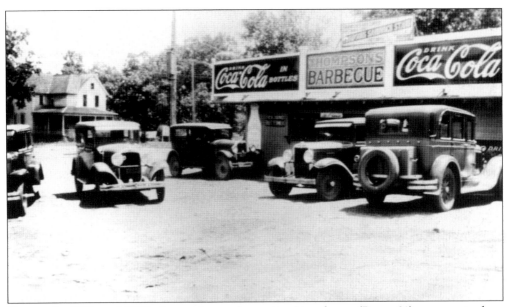

During the 1920s and 1930s the north–south running Lincolnway (Route 31) was a main drag. Along its length were entertainment spots, hamburger joints, and gasoline stations. In order to accommodate increased traffic, the Van Fleet home in the background was moved 100 feet to the east and quarter-turned in 1933. A popular place to eat while out for a drive was Thompson's Barbecue, shown on the right.

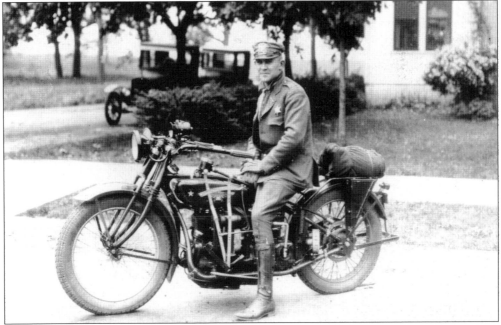

As car prices began to plummet in the 1920s, Lincolnway got busier and busier. With traffic came the long arm of the law and in North Aurora that was Perle Peck. Here Perle is sporting his spiffy uniform, complete with leather gloves and boots on his Henderson four cylinder motorcycle at the corner of State Street and Lincolnway. Bill Glines's home is shown in the background of this 1925 photograph.

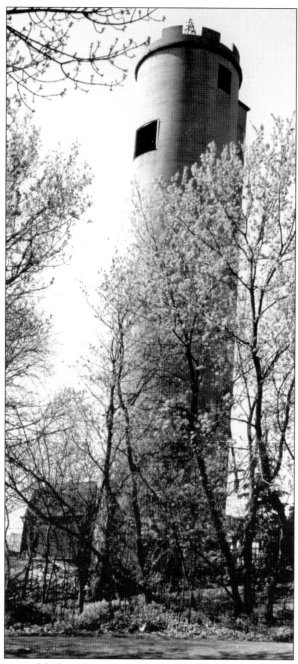

Today this nearly century-old silo is decorated each year with a lighted Christmas tree, which acts as a beacon of cheer and joy for all to see and enjoy. The North Aurora Farmer's Cooperative Company purchased this site, formerly operated by the North Aurora Creamery, and built the 120-foot grain elevator in 1923. The North Aurora Elevator Company took over the operation the following year and installed the first Christmas tree in 1932. Fred Graham Sr. built the first permanent tree in 1935. This tree was replaced in 1984 by one built by employees of Belson Manufacturing Company, Ed Meyer and John Hansen. This community effort included help from the North Aurora Fire Department, North Aurora Lions, and the North Aurora Business Association.

*Four*

# FUN TIME

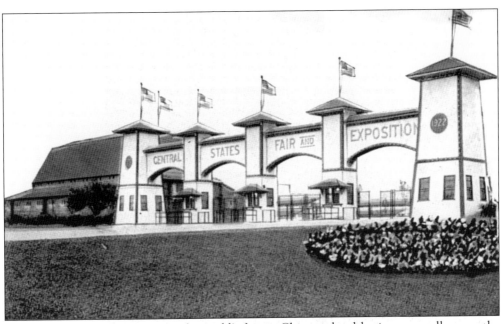

After seeing the drawing power of a world's fair in Chicago, local businessmen all across the country began to make plans for permanent amusement parks that would draw a steady flow of cash customers. Coney Island, in New York, was full all summer. This enthusiasm and the desire to escape the heat of a big city were also felt in Chicago. The banks of the Fox River just west of Chicago in the fresh, country air were a perfect site. Electric lines were constructed from Chicago to several Fox Valley villages. Aurora had a large amusement complex south of town, but the largest park grew up in North Aurora. It was known by many names at different points in its history, but the name that seems to have stuck is Exposition Park. What doomed the amusement parks along the Fox River was Riverview Park in Chicago. The towns along the Fox River turned to movie theaters, miniature golf, and public parks for entertainment.

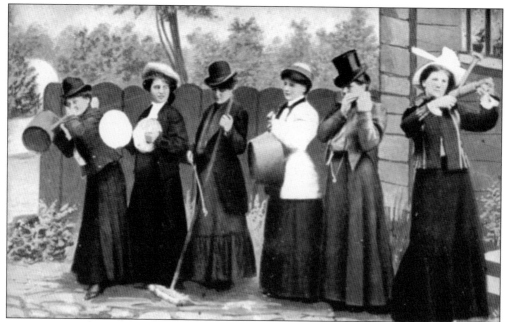

During the Victorian era males determined women's roles. Women were denied entry to professional musical groups such as orchestras. Women were heard loud and clear by suffragette days. To get back at the men and to have a bit of fun thrown in, these German ladies formed their own band made of instruments from their required domain, the kitchen. The ladies in North Aurora followed suit about 50 years later.

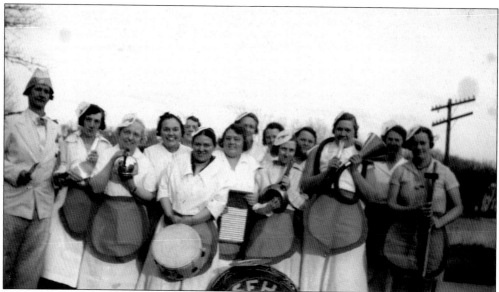

Here is the pride of the Fox Valley—North Aurora's 1930 household band. This aproned, saucy band of players could not only sling hash but could also play a mean boogie-woogie. They are Edna Kurns, Ann Frieders, Grace Tallman, Genevive Stone, Mrs. William Dornback, Evelyn Tavenner, Mrs. Charles Evans, Mrs. John Carlson, Hazel Robinson, Mrs. Harry Kies, Mrs. Elmer Almond, Mrs. Wm. Hammon, and Mrs. Ralph Pottsolk.

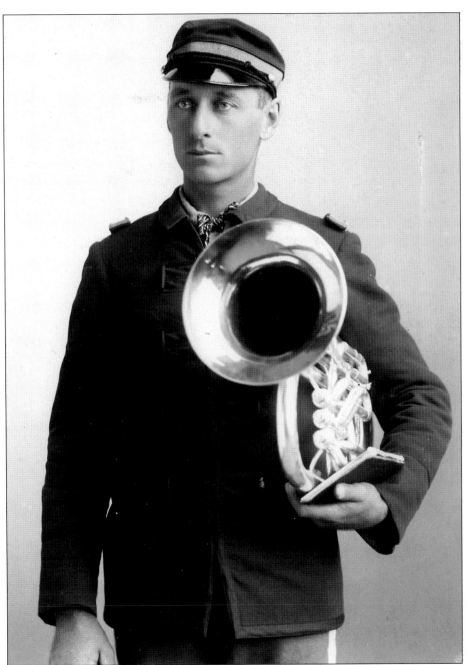

Music was a part of the life of even small villages in the later half of the 19th century. Manufacturers all across the country were busy mass-producing pianos and pump organs and string, brass, and wind instruments. The Schneider family and friends were so musically inclined that they were able to have in-home musicals. Community bands were found in many towns in Kane County. George W. Schneider is shown in this photograph all decked out in his band uniform carrying his music book and a three-valve baritone. Note that the bell of the instrument is pointed straight up and not facing forward. A baritone is a little euphonium but the euphonium has four valves. Schneider was assistant manager of the band. He also played bass in other groups.

Small rural communities, such as North Aurora, were famous for serving good country-style food. Many of the chickens raised on North Aurora farms found their way into chicken dinners sold in the Congregational church's fund-raisers. A tourist in 1927 wrote, "My brother Fred W. was my guest at a very excellent supper or 'chicken dinner' as they call it by the Ladies Aid Society in the church parlor in the little town of North Aurora . . . the ladies have a wonderful reputation . . . people come for miles around to partake of for the modest sum of 60 cents per plate. Eat all you want and groan for hours afterwards."

Photography was a pastime that became popular once inexpensive cameras became available. The Schneider family was one of the North Aurora families that took their cameras almost everywhere, especially on family outings. Sometimes, however, one wanted a more formal, professionally posed image for the family album. Here are George and his sister Emma Schneider.

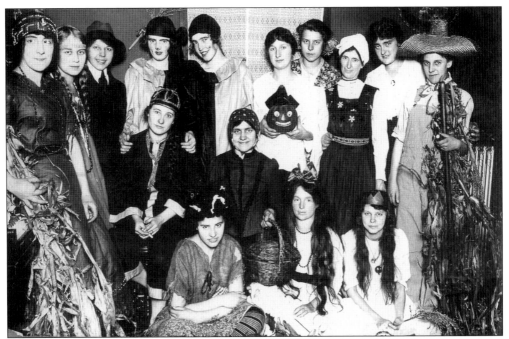

Little girls in North Aurora, like children all over the country, enjoyed playing dress-up. As young ladies, they liked to dress up in costumes for special parties and celebrations. This gathering, held at the Frieders' home, was a Halloween party. This undated image shows a country hick, perriot, perriotte, grandma, pumpkin lady, Rapunzel, and maybe a Statue of Liberty to the extreme left.

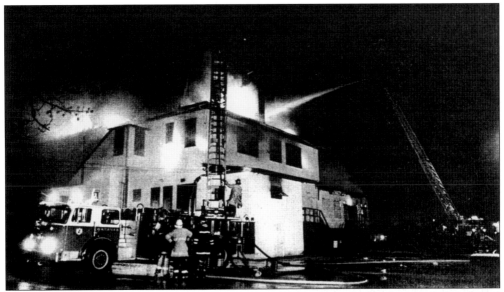

Fox Garden was built in 1922 as a dance hall. Its competitor across the highway was demolished in 1957 to make way for a hotel. In 1987, Fox Gardens burned to the ground. North Aurora fire chief Frank Whelan said that when he and his company arrived, "the north end of the building was in flames and I could see fires starting in other parts of the structure. I felt it was probably gone." The building had no fire detectors, and the fire was determined to be arson.

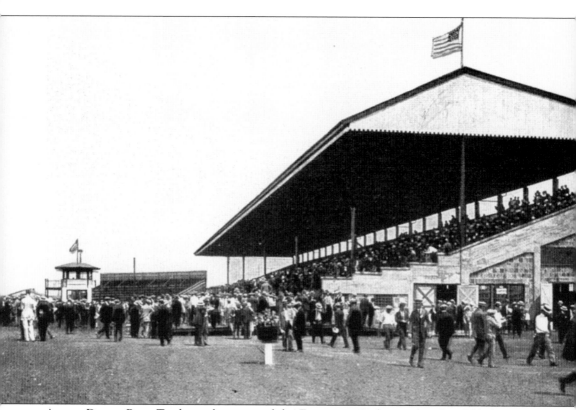

Aurora Downs Race Track was born out of the Exposition Park complex that folded in 1931. When erected in 1921, the racetrack was the largest concrete and steel grandstand in the nation. It was the first place to have legalized horse racing in Illinois, which started in 1922 with grand circuit harness racing. According to the *Chicago Tribune*, "More than 30,000 racing fans crowded Aurora Downs track at the height of the 1937 season." The track was eventually enclosed in glass so that the racing season could go all year. The last day of racing in each season was called Illinois Derby Day. Local horsemen considered the track during it glory days a marvel of excellent grading and surfacing. The general layout of the track was also praised by one and all. In 1957, the 55 acres of land beside the racetrack were cleared for new development. The racetrack itself sat on another 65 acres.

Two lovely ladies, who hope that the two year old will win the fourth race of May 9, are holding Laus outside one of the paddocks at Aurora Downs. The rider was J. Richard at 116 pounds. L. L. Perry was the owner. The purse was $600 for the four and one half furlongs of this race held in 1938. Want to know the winner and call-by-call? Read below.

AURORA MAY 9, 1938          2nd start.

**FOURTH RACE**—Four and one-half furlongs. Purse $600. Net value to winner, $425; second, $100; third, $50; fourth, $25.

| Horse and jocky— | Wt | PP | St | 1/4 | 1/2 | Str | Fin | Owner | Eq odds |
|---|---|---|---|---|---|---|---|---|---|
| LAUS [J.Richard] | 116 | 10 | 3 | 1¹½ | 1² | 1³ | 1³ | B.L.Perry | 29.90-1 |
| POLITE FORD [L.Wilson] | 116 | 8 | 6 | 2⁴ | 2² | 2¹ | 2⁴ | W.Thompson | 2.10-1 |
| OH FUDGE [J.Bryson] | 113 | 1 | 1 | 5¹½ | 5ʰ | 4¹ | 3ʰ | Mrs.E.K.Weil | 3.10-1 |
| JEAN DALE [L.Lake] | 113 | 5 | 8 | 4¹ | 3¹½ | 3½ | 4½ | McCamey&Dea'r | 11.50-1 |
| DOMANIO [H.West] | 116 | 3 | 7 | 7¹ | 7ʰ | 6¹ | 5¹½ | F.Seremba | 5.00-1 |
| TEPERWINE [R.Morris] | 116 | 2 | 2 | 6¹ | 6¹ | 5½ | 6³ | J.A.Blackwell | 37.20-1 |
| MARION DEAR [C.Fields] | 113 | 7 | 5 | 8¹ | 8¹ | 8¹ | 7¹½ | J.B.Blakeney | 16.00-1 |
| MIRA BANE [J.Linton] | 113 | 9 | 10 | 3¹½ | 4¹ | 7¹½ | 8½ | W.A.Mikel | 38.10-1 |
| PEGGY'S SUN [P.Ryan] | 116 | 6 | 9 | 9² | 9³ | 9³ | 9⁴ | S.Pershall | 8.60-1 |
| BROWN CODY [J.Mattioli] | 113 | 4 | 4 | 10 | 10 | 10 | 10 | T.H.Swezey | 64.40-1 |

Time, :23, :47 3-5, :54. Two dollar mutuels paid: Laus, $61.80 straight, $44.00 place, $14.00 show; Polite Ford, $5.00 place, $3.40 show; Oh Fudge, $3.40 show. Winner trained by owner. Went to post at 3:52. At post 2 minutes. Start good from Bahr gate. Won easily; place driving.

LAUS was away with the leaders, opened up a commanding lead quickly and was never in danger, winning with something in reserve. POLITE FORD followed in closest pursuit of the pacemaker throughout but could never threaten. OH FUDGE, taken back soon after the break, came around horses when urged and closed strongly.

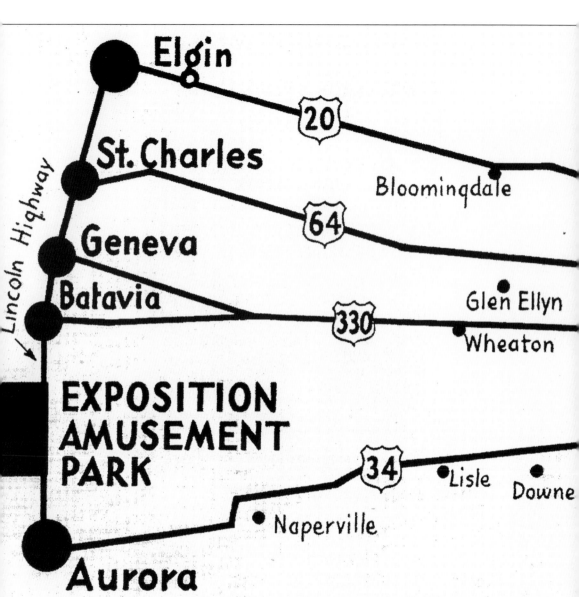

In 1922, Thielen organized the Central States Fair and Exposition in North Aurora. This fun center and fair was built on 139 acres of land bought from Joseph Slaker. The initial investment was $100,000. It started off with a grandstand, numerous exposition buildings for cattle and produce, and a mile-long track for racing. In the late 1920s, a community swimming pool and cottage hotel at the cost of $340,000 were added. Various rides and amusements were on the grounds. At its height of popularity it was the second most popular amusement park in the state surpassed only by Riverview Park in Chicago. Thielen billed his entertainment center as "the Coney Island of the Middle West." The complex was incorporated as a not for profit. Frank Thielen was the "Mr. Show Biz" of the Fox Valley. He was the first to introduce a vaudeville and motion picture theater in Aurora in 1899. Thielen was responsible later for the Palace and Fox Theatres and built Sylvandell in Aurora complete with skating rink, dance floor, and the Rialto Theatre for movies.

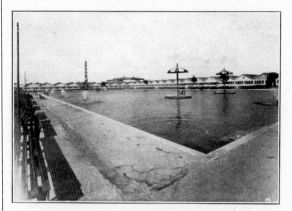
Thielen printed thousands of brochures showing pictures of all the attractions at the park. He always showed a simple diagram showing how easy it was to get to the North Aurora complex. One could take any one of four highways or use one of two railroads. Once in one of the cities along the Fox River, an interurban electric line could take patrons to the doorstep of the park. Once in the park, there seemed to be a million things to do including swimming in the enormous pool or playing miniature golf. It was only open during the summer months and there were plenty of open areas with benches where one could take their lunch and stay all day. Attendance was highest on Sundays. Occasionally it was reported that 85,000 people were on the grounds on a given Sunday.

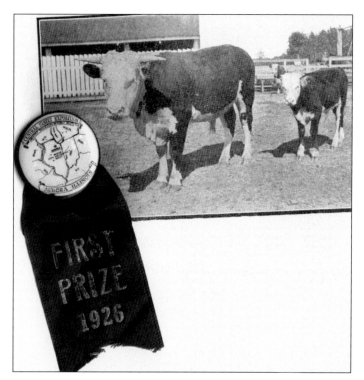

Buildings were used to showcase various animals such as cows, chickens, and pigs. Everything from freshly baked pies, canned vegetables, and fresh produce was on display in the horticulture building. James Rupp and Son took many blue ribbons in 1928, one for their junior boar pig. The winner got $10 for each first place prize in the livestock building.

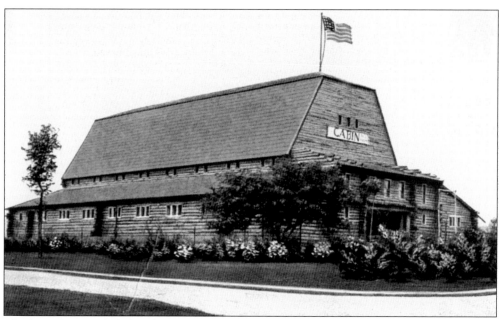

The log cabin was billed as the largest in the world. There was a house built inside the cabin. In 1923, Thielen had the house disassembled and rebuilt in the park and made this his home. Betty Tuftee remembers "that in the early years the cabin was a ball room and a speakeasy in the 1920s. During World War II, Mr. Fox took over the park and made a roller rink out of the Log Cabin. Rose and I skated there and swam in the park pool."

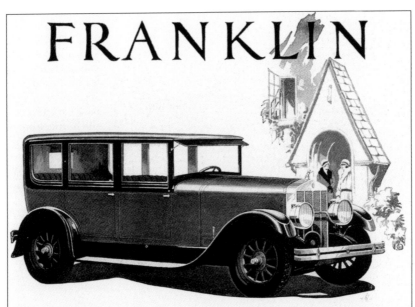

# FRANKLIN

## Try This Most Powerful Franklin

### IT IS THE WORLD'S SMOOTHEST CAR

Do what new thousands are now doing! Take the wheel of the 25th Anniversary Franklin or lounge back in one of its luxurious seats. Either way you will be delighted when its powerful motor gets into action—a combined thrill and ease which no other car can offer.

Powered to hold its own in any company, today's Franklin is smoothed and silenced to a point beyond all comparison. Its freedom from vibration *at all speeds* is constant evidence of the Franklin policy of always keeping ahead.

To those who already own or know Franklins, this is merely an important new extension of Franklin leadership. To those who do not, it is more—an interest-arousing development which leads straight to the most complete and satisfying automobile ownership obtainable.

Coupé now $2490, Sedan now $2790. Fully equipped, F. O. B. Syracuse, N. Y. Inquire about the 25th Anniversary Easy Ownership Plan.

The 25th Anniversary Franklin

A strong reason for the father of the family to take the wife and kids to Exposition Park was that he could see the latest automobile on display. In 1928, he could check out the Pontiac, Oakland, Auburn, Gardner, Moon, Durant, Graham, Paige, Dodge, DeSoto, Buick, Franklin, Marmon, Packard, Nash, Studs, Chrysler, and Reo cars. Dealers from Naperville, Batavia, Aurora, and Chicago displayed these cars. The Franklin cars came from the Franklin Drew Company of Aurora. The Nash automobiles also came from Aurora. Nash automobiles were priced from $865 to $2,090. In addition to the automobile show, there were International Harvester trucks on display. To add additional spice for the men, there were three airplanes on display—the Travel Air, Waco, and Velie Monocoup. This same year Johnny Livingston placed second in the free-for-all course at the National Air Show in the Waco model.

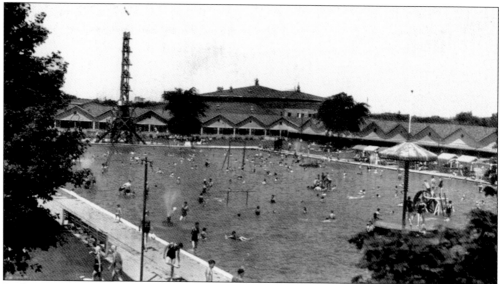

In the center of the park was one of the largest fresh-water pools in the world. "Swim in drinking water" was advertised. It was made of concrete and ranged from one to ten feet deep. It covered an area 360 feet by 160 feet. There were geyser fountains and towers for diving and plenty of rafts and water toys in the water. It could accommodate more than 5,000 swimmers. The hotel apartments were along one side of the pool.

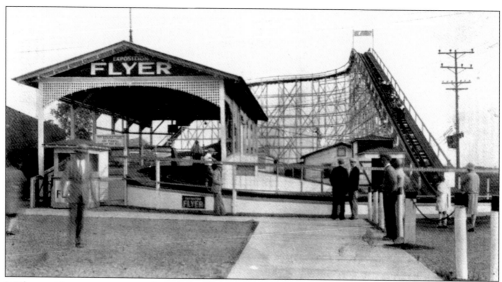

Midway rides were in great abundance by 1923. The roller coaster, called the Exposition Flyer, was popular among the teenagers. The four abreast horses and animals of the merry-go-round were a treat for children of all ages. Fred Graham Jr. worked on the Flyer. "I was hired as a water boy for the 85 men who worked building the Exposition Flyer. I had to carry two buckets of water and a dipper. One heavyset carpenter was always hollering 'water boy!' It was his way of goofing off." A cyclone destroyed the Flyer in the 1930s.

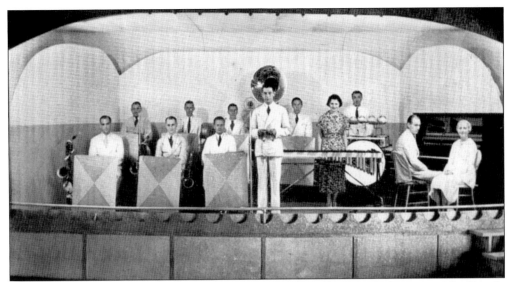

Music played a big part in keeping the atmosphere of the fairgrounds festivities. The Seattle Harmony Kings Orchestra was the house orchestra in the Log Cabin Ballroom and the Peerless Pennsylvanians (shown), a 12-piece orchestra, played there in 1928. This band was heard on the airwaves of radio stations playing the newest dance music. Cevonne and his brass band could be heard playing popular Sousa marches on the grounds.

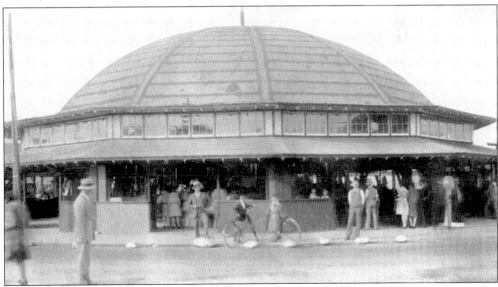

Fred Graham Jr. also worked at the snack bar when the merry-go-round was completed. "On the Merry-Go-Round was a bar that had gold rings on it. If you, as you went around, were able to snatch a ring you got another free ride. Rides cost 5 cents. My weekly pay was $10." The merry-go-round was enclosed in its own building which helped protect the carousel from the weather. Graham also took tickets at night at the Aeroplane Ride.

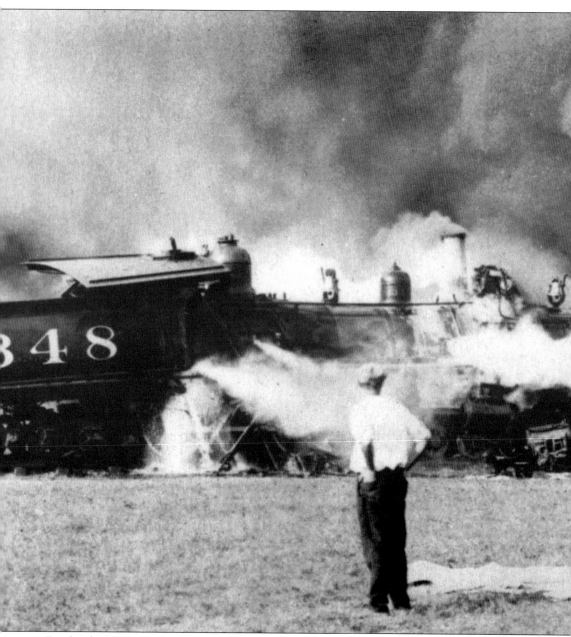

Frank Thielen knew how to keep his complex full of happy, paying customers. Like in old Roman days at the Colosseum, he gave them dramatic contests. The ultimate thrill was to have two old-fashioned steam locomotives crash into each other. He did this popular mayhem event twice. One time it was like a two-ring circus event with a horse race thrown in to boot. The first steam-locomotive wreck was staged in 1923. For the Fourth Annual Fair in 1925, he pitted two locomotives against each other to settle the "evolution/anti-evolution" question. Wooden passenger cars were added to each locomotive according to historian Fred Graham Jr. "When they collided it tipped over smoke pots which started the cars on fire. Dynamite was used to explode when the locomotives hit." There is no record of who won. Also at Thielen's entertainment center were automobile races with cars and drivers from Indianapolis. They also had automobile

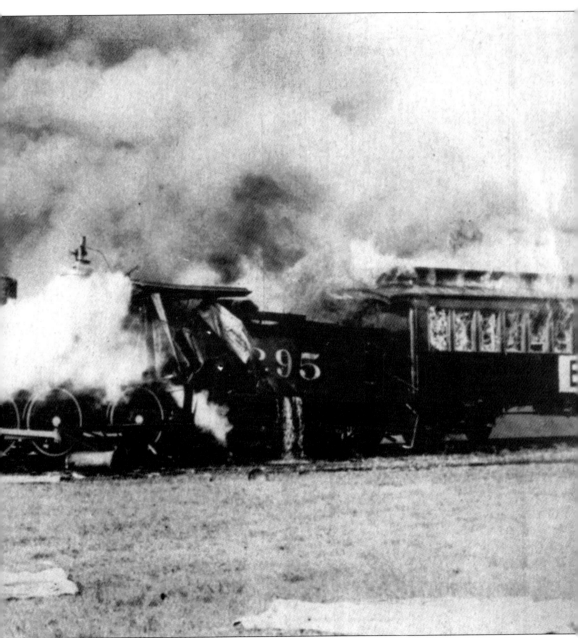

polo, which used stripped down Fords with a driver and passenger. The passenger used a large mallet to try and drive a soccer-sized ball into a net. At one of these competitions one of the drivers died when his car rolled over and the roll bar crushed him. One year, air ace Billy Brock flew down over the field and picked up Lillian Brock from a racing car with a rope ladder from his biplane and let her wing walk. There were plenty of quieter activities for the ladies also. On the grounds there was a women's building where the women could enter their pickled beets and show off their handmade quilts and other hand-worked items. The younger women loved the Walk-A-Thons held in the women's building that were actually dance-till-you-drop contests. In 1928, there was a Better Babies Conference on the grounds.

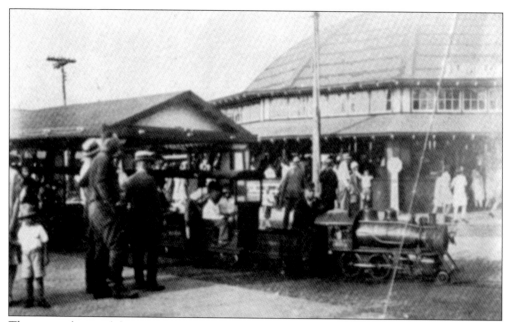

The interurban rail line was on the east side of the Lincoln Highway with access to the fairgrounds by way of an underground tunnel from the station. Different acts were featured each year, but one of the most popular rides was not found on the midway. Two miniature locomotives made their way through the park carrying guests just as is found in many parks today.

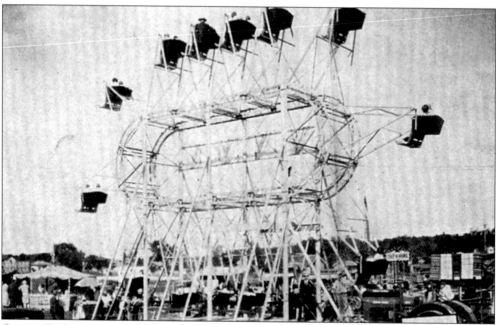

George W. Ferris's massive wheel was all the talk of the 1893 Chicago World's Fair. He put 36 wooden cars that held 60 people each on a wheel to rise into the air. Exposition Park's version of the Ferris wheel was an elliptical called the Swooper, which could hold a total of 18 people and raise and drop them in pairs.

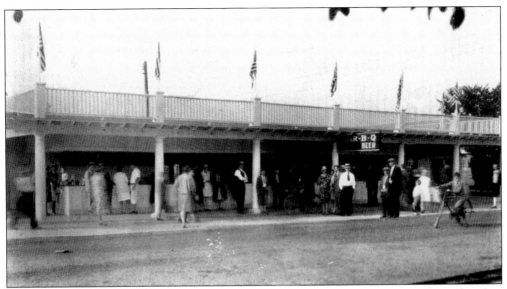

Just as in modern-day amusement parks, there were plenty of places throughout the park to buy food. Shown here is one of the midway refreshment stands. Notice the Bar-B-Q and Beer sign and the use of the American flag to lend a patriotic seal of approval to the Exposition Park. After refreshments, one could stroll over and see a girl buried for a week in an underground box through an observation pipe.

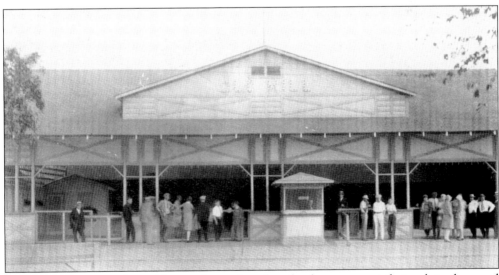

The Old Mill, a scenic boat ride, was the perfect place for the guys to get their gals in the mood for love. It was located near the roller coaster and an open air dance pavilion. In 1924, the band of Fred Dexter was playing tunes on summer evenings that filled the air of the park with mood setting songs that turned the Old Mill boat ride into a virtual lover's lane.

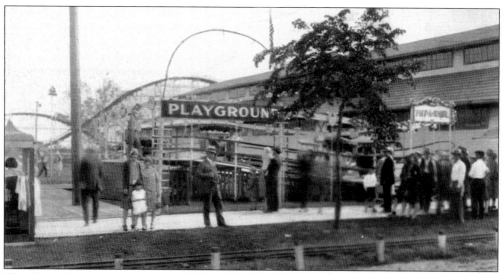

The tilt-a-whirl was another of the 1920s rides that has become a classic. The lady to the left is selling tickets for the ride out of a small booth. To the front is the track for the train ride and in the distance is the roller coaster. The purple martin house in the background on the left on the pole provided a home for the birds that kept the mosquito population down. The confident man staring directly at the camera just might be the park's president Frank Thielen.

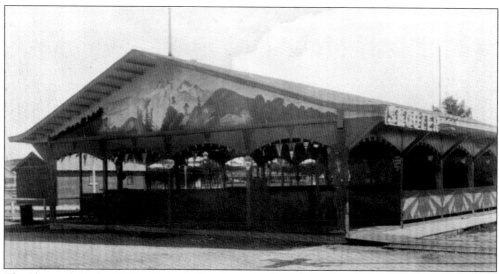

The Skooter billed as "A You Drive-It-Fun Sensation" is yet another classic ride that is still found in amusement parks across the country. Notice the extensive artwork under the eves of the building depicting a mountainous landscape. An electric sign and lights outline the attraction. Hanging banners inside also added to the excitement of the colorfully painted bumper cars that are ready for battling drivers to smash into each other.

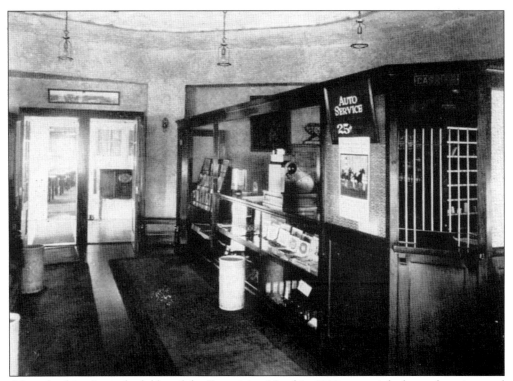

After checking in at the lobby of the Exposition Hotel in 1923, one might buy a fine cigar and check out the latest harness race to be run in the park. Before leaving, the visitors could study the panoramic shot of the entire park placed over the double doors into the lobby. This year one could see Violet and Daisy, the Siamese twins from Texas, on the midway.

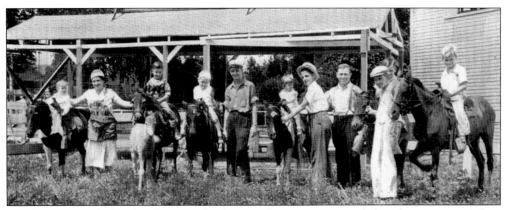

For those unsatisfied with riding wooden horses, there was a one-eighth-mile pony racetrack at Exposition Park. Although these family members are not racing, just going for a stroll with mom and dad. Culture was represented also. E. S. Barrie Jr. was director for the Fine Arts Department of the exposition in 1923. Paintings, watercolors, and sculpture were on display. Max Bohm's famous "Crossing the Bar" was on sale for $10,000.

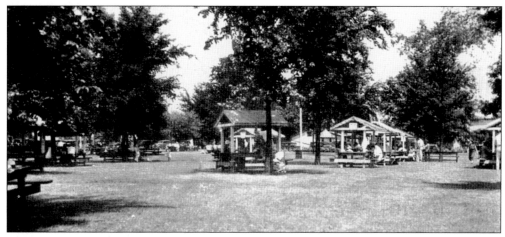

The people of North Aurora could always find a place close to home to picnic, but a picnic on the grounds of Exposition Park offered more. The park provided 10 acres of picnic groves with tree sheltered tables in case of rain. Artesian well water was on hand. "No picnic too small, none to large," was the park motto. There was also a lunchroom and restaurants on the grounds.

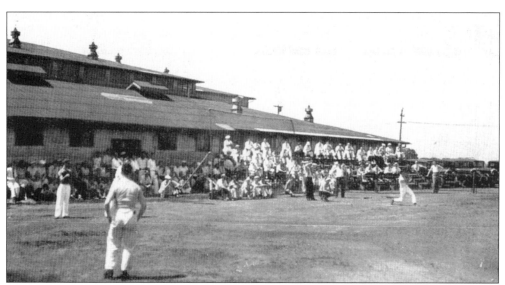

Local baseball teams played in the fairgrounds, as did professional teams. One time the Kansas City Monarchs, a black basketball team, took on the famous bearded House of David players. "Red" Grange and his football team from Northwestern once used the field. The boxer Max Baer put in an appearance in 1932 and rodeos were always popular events.

In 1923, Thalero's Circus appeared in the Park. In later years the Hagenbeck-Wallace Circus featured not only three rings but also two stages under its big top. They bragged, "NO Circus is complete without clowns. Fifty of these funny fellows kept the audience in roars of laughter at every performance. Pete Mardo shown here was one of their most original clowns on the 'sawdust trail.'"

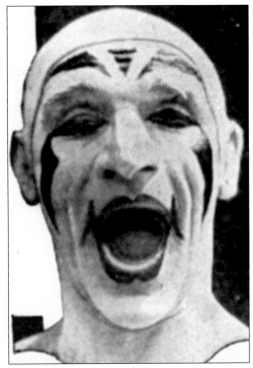

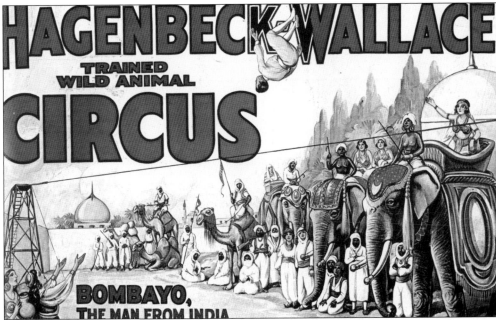

The Hagenbeck-Wallace Circus had both their headquarters and winter quarters in Peru, Indiana. By 1907, the circus was owned by Ben and John Wallace and consisted of a show that filled 28 railroad cars. It bragged about its 16 elephants and was the only other circus to rival Ringling Brothers and Barnum and Bailey. The circus closed in the 1940s and its more than 150 colorfully decorated wooden wagons were set on fire. The metal parts were sold to benefit the war effort.

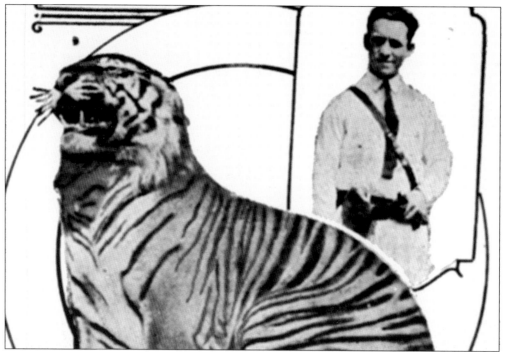

One of the most famous acts to play the Hagenbeck-Wallace Circus was Clyde Beatty. In 1928, he was billed as America's youngest wild animal trainer. Beatty presented a mixed group of 30 Black-Mane lions and Royal Bengal tigers, natural enemies, inside his steel cage arena. In 1935, he left Hagenbeck-Wallace to join the Cole Brothers Circus.

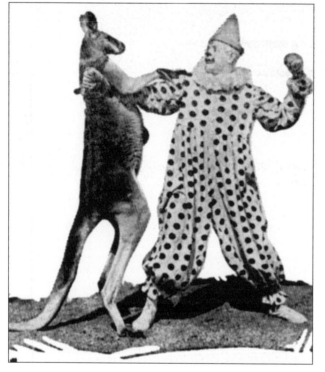

Hagenbeck-Wallace had "BOB" a champion boxing kangaroo facing off against "Kinko" the clown for boxing fans. The matches lasted four rounds. One time they brought in a whale and another time the Monkey Village, which was located on a large island surrounded by a 10 foot channel where visitors could see older and baby monkeys swimming and diving.

# *Five*

# SCHOOL DAYS

Education was an early concern of the federal government. The Northwest Ordinance of 1787 stated, "Schools and the means of education shall forever be encouraged." The first school laws came into existence in 1825 when school districts benefited from a compulsory tax base that was to provide for white children between the ages of 6 and 21. A few years later, in 1829, the taxation part of the law was removed, thus making the education requirement all but useless. John Peter Schneider realized how important education would be to the growth of the village he founded and had a log cabin built on his land soon after the early settlement days of the late 1830s. At times he was the president of the school board and even kept records of expenses for the various early schoolhouses in his personal diaries. North Aurora has had only four school buildings before 1932. The village owes a debt of gratitude to a former teacher and a small group of students who conducted interviews with some of the older residents asking about their school days. Shown here are some of the students interviewing Paul Slaker with A. G. Thurston to the right.

Adventure was second nature to North Aurora's most famous early educator, James D. Fox, who came to Illinois to teach in 1857. He served in the Civil War as a second lieutenant of Company H of the 16th Illinois Volunteer, and he was admitted to the bar in 1865. Fox grew restless and turned to real estate before finally settling into his role as a historian and writer. He wrote about the early histories of Aurora, Kane County, and Illinois. His poetry about the life of the soldiers of the Civil War and the Spanish-American War is exceptional. The following is an excerpt from his poem, "Peace on Earth and Good Will to Men":

No more the crimson flood
Of patriotic blood
Invites the vulture or supplies the sod
With fertilizing dead
To crown one only head
Or make of mortal man a demi-god,
Oh wealth of golden rule;
Oh, joy of hearth and school;
The artsman's voice and halcyon call of bell
Now aids to shield the land
From war's relentless hand,
Where plenteous peace and sweet contentment dwell.

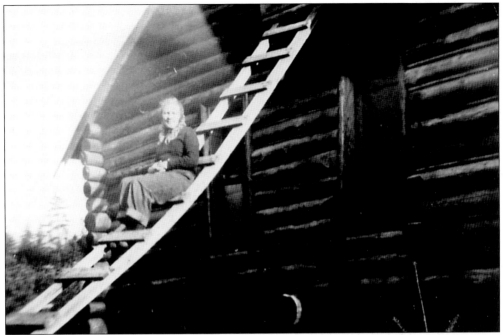

Some records show that John Peter Schneider built the log cabin schoolhouse in 1844 and other accounts place the date as six years later in 1850. It was the only schoolhouse for miles around serving children living on both sides of the Fox River. It was later used as a storage shed. The log cabin above is of the size and probable look of that first schoolhouse.

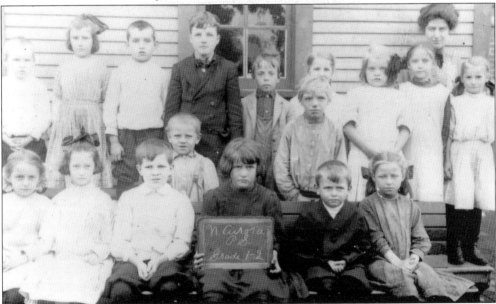

Evelyn Tavenner's great grandparents moved to North Aurora in 1834. Their farm was north of the Slaker farm. Her mother, a Schneider girl who married a Winter boy taught in North Aurora school No. 2. She was one of the first graduates of West Aurora High School. Tavenner remembers that as a young girl there were still American Indians around at the time of this 1909 photograph. This photograph shows the first and second grades that year.

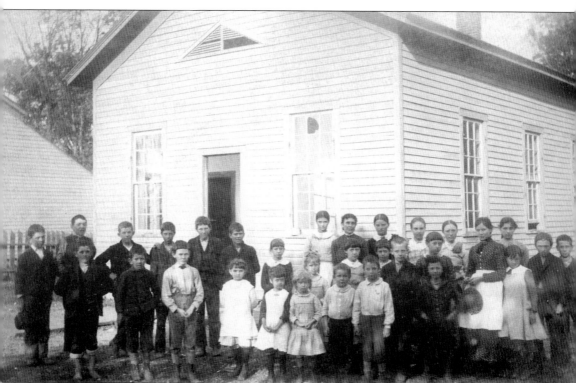

John P. Schneider, president of the school board in 1863, noted in his diary, "February 11, Wednesday. Put up notices for builders . . . for a schoolhouse. . . . One notice put up on John Lyon's livery stable, and one on Buck's store. April 20, Friday. Went to Aurora to finish up the agreement with John Morris. . . . He is to do all the carpentry work, painting, and furnishing all materials except mason work for $525.00." Here is a fictional tale about life in school No. 2. "The schoolhouse was as sleepy as a warm day in May. Who could resist swatting flies and erupting into giggles? Mr. Van Fleet was plowing just outside the open windows. Boys in the room silently imitated the 'Hi-yas' that he yelled to his team. At lunchtime the boys ran to the Fox River for a cool swim while the girls ate their lunches outside in the breeze."

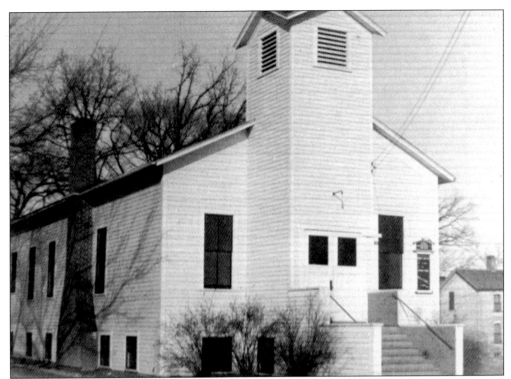

North Aurora's early school building served also as the community center and the Congregational church. This schoolhouse No. 2 was used from 1863 to 1886 as a one-room schoolhouse for grades first through eighth, and from 1863 to 1964 it was used for community and church meetings. This 1925 photograph shows the church with a half-raised basement.

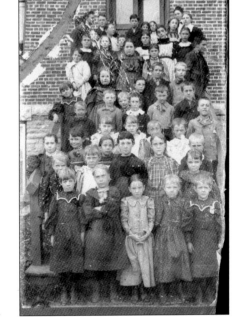

When the new school was built in 1886, the old building was moved to a location two lots to the north. The new school was built on the corner of State Street and Lincolnway. This red brick, two-story school had a French gambrel roof line at the time of this photograph. The bell tower structure jutted outwards from the building in front.

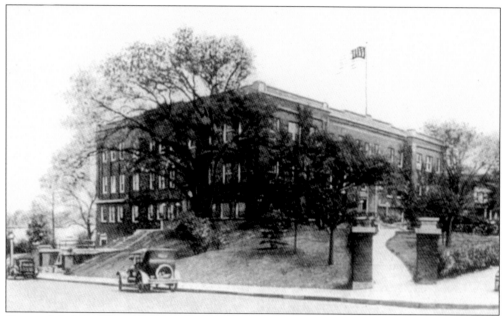

"I attended the red brick school (#3). We had two grades together in our room. There were indoor washrooms by this time. When I graduated from eighth grade, I had a free choice of which high school to attend. I chose Batavia and graduated in 1925. I used to ride to high school by trolley that went from Aurora to Elgin (this trolley ran on Lincolnway and went right past the school.) The ride to Aurora cost 10 cents," noted Evelyn Tavenner.

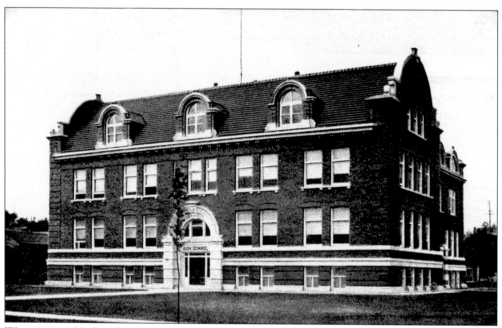

West Aurora High School was another choice for North Aurora students. This postcard shows the new high school "on Galena, Blackhawk and Walnut Streets" completed in 1905. This building, modern looking in its day, is still standing and was used as a private school for a time.

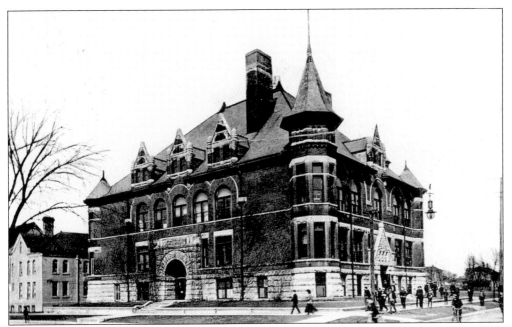

The third attendance choice for North Aurora students was East Aurora High School. In 1909, classes were held in this spectacular high Victorian edifice that would be at home on Kimball Avenue in Chicago.

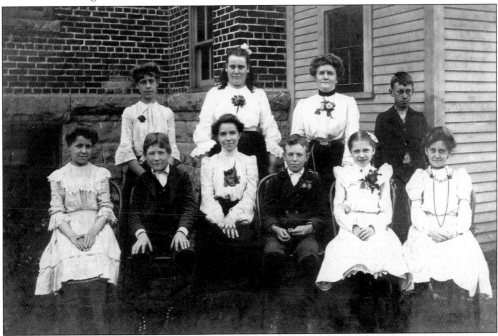

Jo Rippinger wrote, "My favorite experience happened one day when the regular teacher was gone. This boy tied a girl's braids to his inkwell. When she got up, she got a real jerk. Well, I chased the boy around the room, cause that made me mad. The substitute teacher did what everyone did in those days where there was a problem; she rang the recess bell to stop the free-for-all. Oh, that boy was a rascal!"

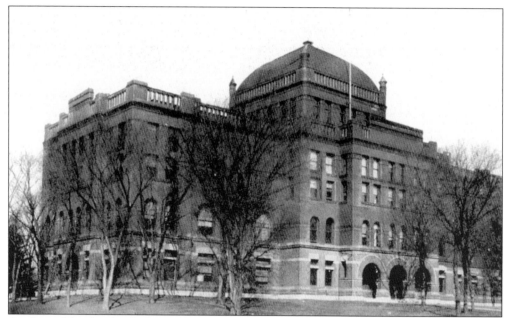

At the red brick school, the seventh and eighth grades studied reading, writing, arithmetic, spelling, geography, and history in rooms on the second floor. Grades first through third were in one room downstairs and fourth through sixth were across the hall. Graduation for the eighth grade was held at the courthouse in Geneva for all rural schools at this time.

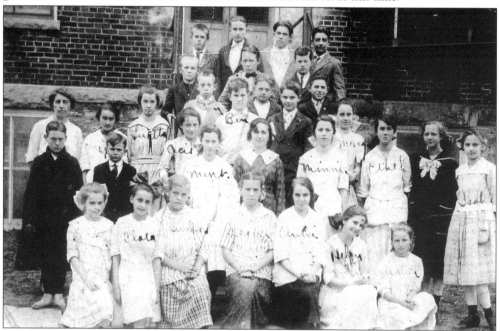

Emeline Messenger wrote, "I remember we gave plays for our teacher, Miss Bircher. With a portable wall removed, we could use the platformed stage on the north end of our room. Well one Thanksgiving we gave a play with John Alden, Miles Standish played by Richard Clark, and Priscilla played by me. I remember I had to take the arm of John Alden played by Fred Sandell and walk up onto the stage. I was horribly embarrassed. Now, as I look back on it, it was fun."

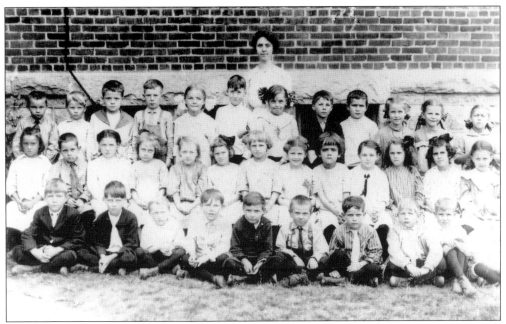

Were the "good old days," so good after all? This is the elementary school class of Miss Gannon in 1915. There is one teacher and there are 35 students sharing desks. Boys had to wear ties and there is not a smile to be seen among them in the photograph. The teacher must have had a difficult time with so many to teach.

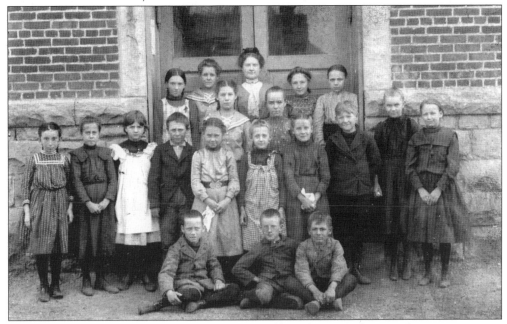

According to Paul Slaker, the North Aurora school board once took unusual measures to get a class under control. "The board called Bart Weaver for help. When he got off the Chicago and Northwestern train from St. Charles, the whole class was there to size him up. He had only a briefcase and a hickory stick." The new teacher hung the hickory stick over the map and had only one encounter with a student.

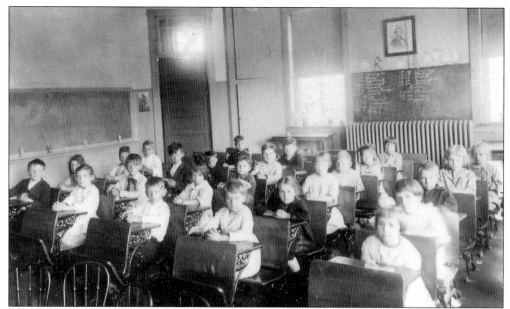

This picture shows the inside of the third North Aurora School in 1922 of the first, second, and third grades. Teachers taught to the constant hiss and clanking of the radiators in the winter. Most of the students are identified except in the fifth row.

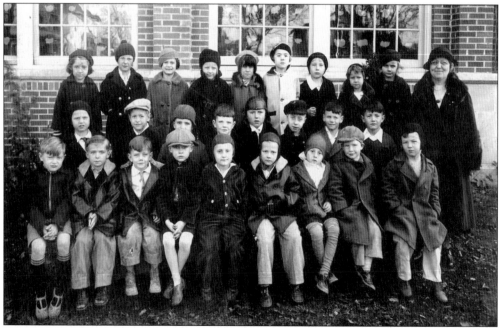

"My grandfather was John Slaker. I attended the third North Aurora School. I remember the recesses that we had on the dirt floor in the basement when we couldn't go outside. My teacher was Miss Tallman. We had a gravel playground and a merry-go-round. Everybody liked to play on that. We also played kick the can, hop scotch, and marbles. One of the pleasant remembrances was going to the island during lunch hour and picking wild flowers," remembers Betty Tuftee.

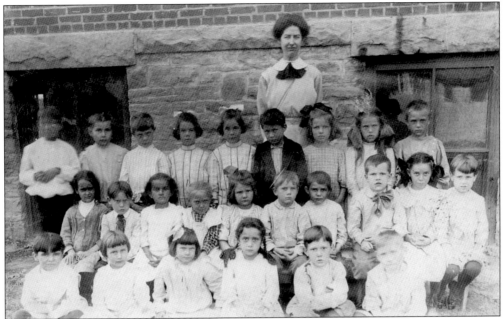

Jo Rippinger's father was from Luxemburger and a logger by trade. She only went to the North Aurora School No. 3 in 1907. She remembers, "The schoolgirl of that year wore dresses with high necks. Her hair was all pulled back. She wore an apron to school. In her hair she wore a tissue paper bow in her braids or in her curls. The boys wore knee pants and long stockings. Everyone wore shoes. Girls wore the high button kind up to the ankle."

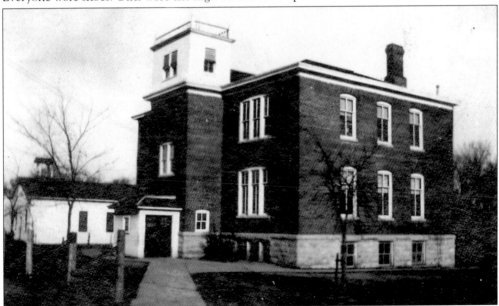

The schoolhouse caught on fire in the early 1890s. Damage was confined to the second floor. Paul Slaker recalls hearing about painters who had originally worked on the school, leaving paints on the second floor. Perhaps the paints had spontaneously combusted. After the fire the school was remodeled with a flat roof and the roof was extended to the walls, eliminating the gables housing the windows as shown in this 1920s photograph.

Before the typewriter became popular, penmanship was an important class in early grade classrooms. Students were taught to sit erect in their desks and use a fine-pointed pen with a good springy nib. One's left hand rested lightly on the desk holding down the paper while the right hand did the writing with the thumb and the first and second fingers lightly grasping the pen. The student had to be skilled as to just when to stop writing, dip the pen into the ink well and have the writing appear seamless.

Hours and hours were spent each week in mastering the standardized letters displayed on the chalkboard for imitation. The letters had to be slanted between 30 and 60 degrees to the right. Students had to learn how to adjust the pen pressure in order to form some of the elaborate letters. Girls had to master even more difficult letter swirls and were held to higher standards of penmanship.

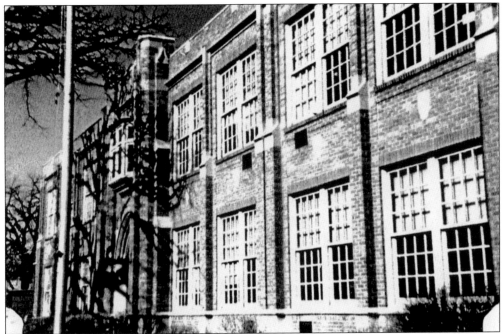

The first contractor hired to build school No. 4 bid too low and the school was only partially finished in 1932. Bill Erickson, secretary of the school board sought help from the government and secured a Works Progress Administation grant to finish the school. By 1935, everything was complete except the Lincolnway entrance. By 1954, the state mandated that elementary school districts should become part of a district that included a high school. At that time North Aurora School District No. 155 joined West Aurora School District No. 129.

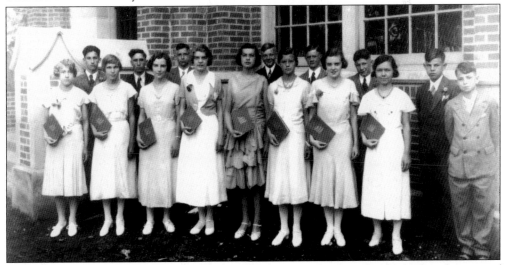

Homer Offutt remembered, "My father was the Secretary for the school board at the time of the second phase of the building of the school. He insisted that a scout room was a part of the building with a fireplace. For some reason, there wasn't an architect on the job. . . . When the building was almost completed, the principal who had been a basketball player had to visit schools in Aurora to measure how high the baskets should be put in the gym." Pictured is the class of 1932.

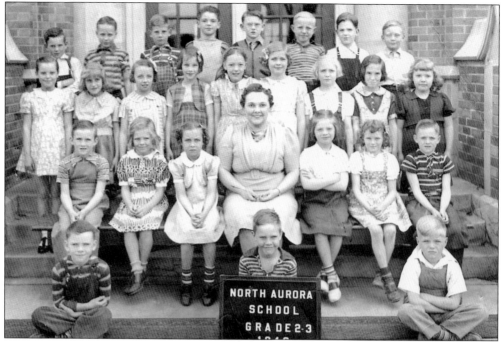

Since money was tight when school No. 4 was being built, the story goes that to save money the blackboards from school No. 3 were salvaged and installed in the new school. This means that the blackboards there could possibly date back to 1886, making these blackboards over 90 years old in 1977 when the school was closed. This 1940 photograph is of grades two and three.

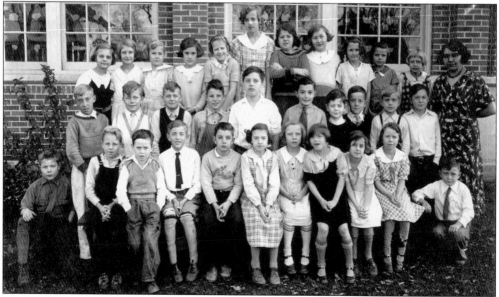

W. Alfred Wilke was chairman of the building committee that built North Aurora No. 4. Margaret Wilke noted, "During the Depression, when money was hard to come by, the school served as the center of community life. We had silent movies for five cents. Dances cost 50 cents. We did have a basketball team called the Crescents. When they played, the whole town-all five hundred and fifty-attended the games!" This photograph is of the 1934 third and fourth grades.

Graduates from the North Aurora WPA school received official certificates acknowledging that they had graduated from an "Elementary School of Kane County" and that they were eligible to attend one of three high schools in the area. This is Robert (Bob) Frieders certificate of promotion dated May 28, 1940, and signed by E. E. McCoy, county superintendent of schools.

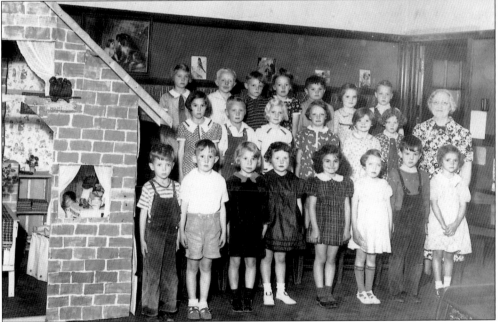

This 1939 interior photograph of first grade offers a rare glimpse of the activities engaged in by the students at that time. To the left is a student-constructed small house of cardboard where various play activities took place. In the background are the famous old blackboards and a calligraphy chart along the top edge of the blackboard.

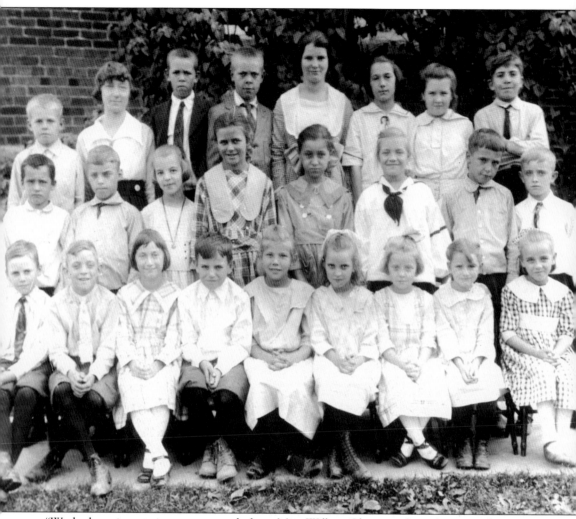

"We had art instruction once a week from Miss Wilber. Oh, yes, when changing classes, we marched to the next class as the *Stars and Stripes Forever* was being played on the old windup Victrola. The fire escape was waxed for fire drills," reminisces Margaret L. Wilke whose father was W. Alfred Wilke. The Wilkes are descendants of the Erickson family who moved to North Aurora in 1879. Members of the North Aurora class in 1922 shown from left to right are as follows: (first row) Harold Ekstrom, Mike Plum, Marie Schwickert, Roy Hagerman, Florence Croyl Windett, Katherine Plum, Ruth Ekstrom Macgruder, Pauline Winnmaker, and Pearl Hagerman; (second row) Harold Stumbaugh, Bill Johnson, Helen Hartsburg, Helen Berringer, Louise Kline, unknown, Ira Johnson, and Fred Graham; (third row) Ed Worth, Miss Koehler, Roy Anderson, Melvin Anderson, Irene Hagerman, Anne Schwickert, Margaret Masse, and unknown.

*Six*

# ARCHITECTURE

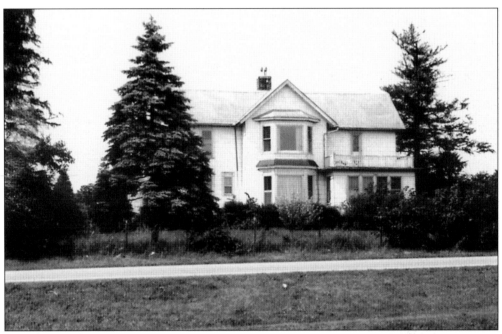

Early farmhouses started out small and were added to as family members and functions performed in the house were increased. The Slaker, and later Tuftee, home shown above is an example of this. It served several generations going from a one-family home to a two family and finally back to a one family before it was demolished in 1996. Most of the houses in North Aurora were much smaller than this one. Houses built in the early town in the late 1800s and early 1900s were mostly based on the cottage or bungalow style that was of a modest size on a compact footprint. Relatively low-cost house plan books had been available since 1837. The first, *Rural Residences*, was by architect Alexander J. Davis. Andrew J. Downing published the widely read *Victorian Cottages* in 1842 and *The Architecture of Country Houses* in 1859. And by 1908, one could order plans with or without materials from companies such as Sears Roebuck and Company and Montgomery Ward.

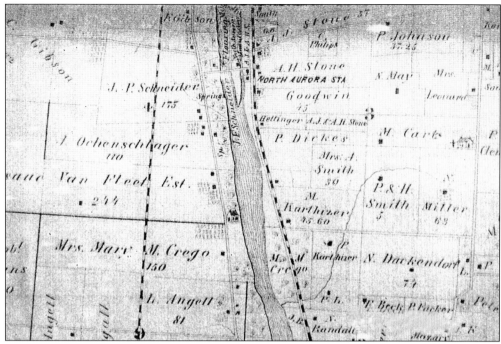

In 1872, the area now known as North Aurora was mostly farmland worked by the Schneider, Ochenschlager, Van Fleet, George, and Gibson families on the west side and a greater number of farmers on the east side. A. J. Stone and P. Dicke on the east would soon subdivide their land to provide housing sites. In 2006, 20 bodies were excavated on the Miller plot. One was a Civil War veteran.

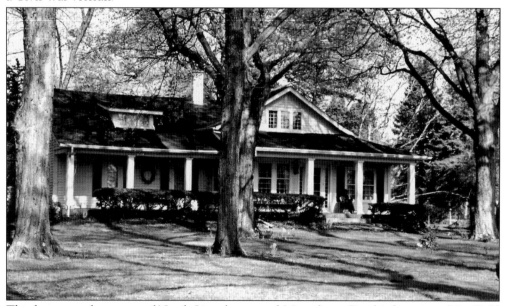

This house on the corner of North Lincolnway and Mooseheart Road is known as May Field and a sign in front states that it is "c. 1850." William George applied for the name under an act providing for farm names in 1915. It was built by, and home to, the George family until 1983. This house is showcased on six lots of the George Addition.

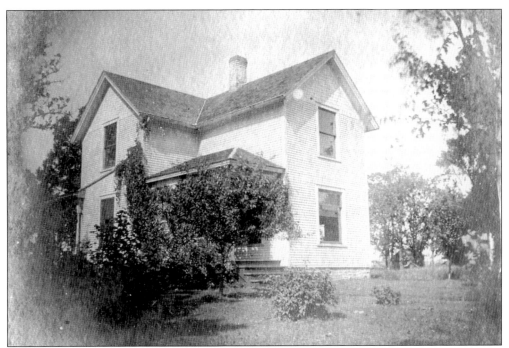

Built by George Hawksley, this house once stood where the Shell Station is on Lincolnway. After Hawksley's death, his wife Nora Slaker Hawksley raised her daughter Vera here. Betty Tuftee enjoyed visiting her aunt Nora and watching the goldfish in the pond.

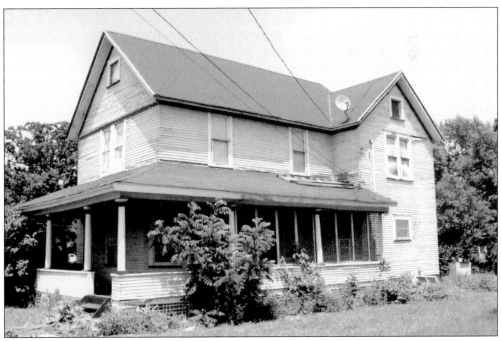

The earliest known owner of this site is Gotfried and Juliana Dietrich. This was a very expensive house for its time. The "L" shape and the wrap-around porch with columns give this impression. Notice that the back section of the porch is screened.

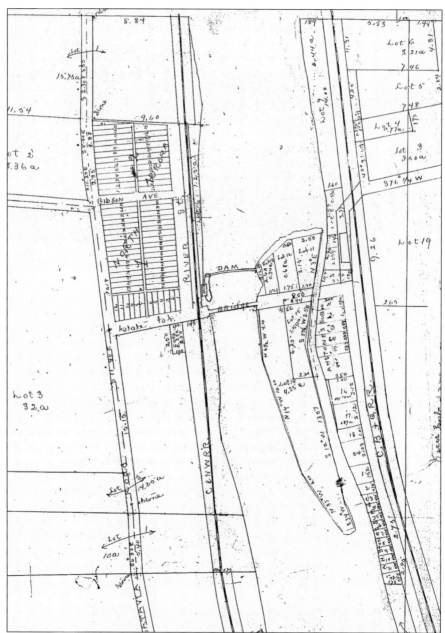

Landowners shown on an 1874 map are Baldridge, Stone, Brown brothers, and Alexander Hamilton Stone, but the southern portion of the six-acre island has no owner identified. A. H. Stone has started subdividing his east side land on both sides of the Chicago, Burlington and Quincy Railroad (CB&Q) by 1874. This 1885 Kane County assessor's map shows Stone's Addition and Dicke's Addition as well as four lots platted for industry on the island. The southern portion of the island was heavily wooded and never divided for either business or residences except along the roadway. The original town of North Aurora containing blocks 1 and 2 and bounded by State Street to the south, River Street to the east, and Aurora and Batavia Road to the west is shown on the west side of the river. Both the Chicago and Northwestern Railroad and OO&EBV Railroad freight lines ran on the west side of the river while the CB&Q ran on the east side.

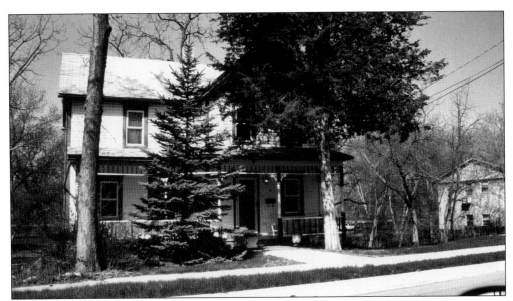

This house at 42 Grant Street, built around 1900, sits on lots 2, 3, and 4 of the A. H. Stone Addition. Stone sold these lots to Charles Goyette in 1885. Alexander Hamilton Stone came to North Aurora in 1868 when he and his brothers together with Richard I. Smith, I. M. Tiffany, and Julius Brown organized the Sash, Door and Blind Company according to John F. Schneider.

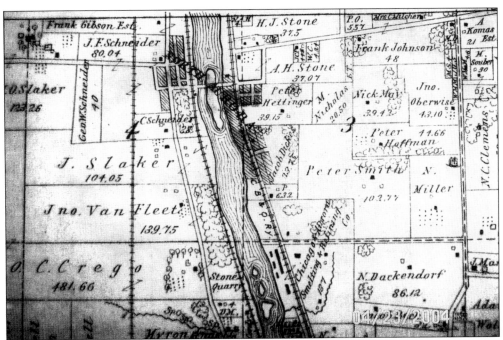

Compare the names on the farmland in this map with those in the 1872 map. There is now an area identified as "North Aurora" in 1883, even though the village would not be incorporated for another 13 years. There are also blocks of houses shown on both sides of the river. Schneider has begun dividing his land among his sons, and the Ochenschlager family has changed their surname to Slaker. A few acres had changed hands on the east side by this time.

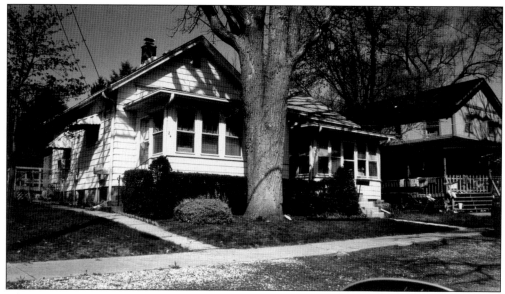

Alonzo George sold this lot to Peter Nelson in 1888. It was sold three more times before Michael Daleiden bought it in 1913 and built a house in 1920. Since then many changes have taken place. One can see the two porches that have been enclosed and the added deck in this photograph.

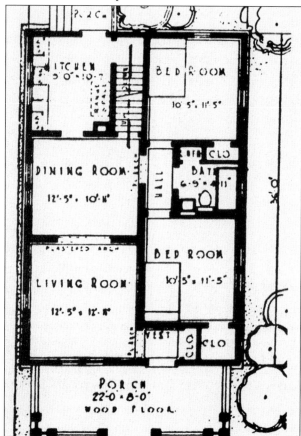

Here is a floor plan of the popular one-story house at the beginning of the 20th century. Look at the differences from popular plans today. Bedrooms and closets were small. And the dining room was equal in size to or larger than the living room. This much-used room was the center of the house. Most meals were eaten at home and lively discussions often happened after dinner until the advent of television.

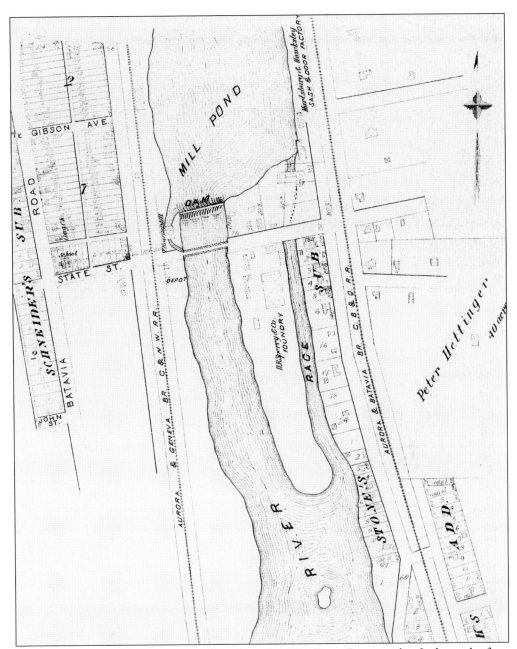

This drawing of North Aurora was taken from the 1892 Kane County atlas. It shows the flour mill located on the west side of the dam, the Hartsburg and Hawksley sash and door factory on the east bank and the D. R. Sperry and Company foundry on the island. The two blocks on the west side marked 1 and 2 are the original blocks of the town of North Aurora. Stone's (on the east side) and Schneider's (on the west side) subdivisions are platted, and workers in the businesses were beginning to build houses to live close to their work. Gibson and Charlotte Streets have been renamed Oak Street.

August and Hannah Sandell built this cottage in the early 1900s. Their son John built the garage and may have enclosed the front porch when he was the homeowner. A later homeowner, Don Moutray, added the back porch so access to the basement could be had without going outside. The coal room with a sliding door is still in the basement, and the house has the original hardwood floors and plaster.

Hannah Sandell is standing in front of her house in this photograph. The plain foursquare house next door is behind her. August and Hannah changed their surname from Johnson to Sandell when they first came to the Fox Valley because there were already eight August Johnsons in the area.

This has been the site of the North Aurora Mill and later the Monarch Automobile Company. In 1893, the North Aurora Mill sold the property to John Thorsen who sold it to John Croushorn in 1904. Croushorn ran a popular boarding house and tavern here. His daughter Vera helped the young widow, Hannah Sandell, with her six young children.

As the family of workers grew, simple cottages were expanded using attic space for more bedrooms for the family's children. This well kept cottage sites on block 23 and 24 of the original town plat and was once owned by John Sandell.

This is Schneider's first subdivision of 13 lots. The street running on the right has had many names, Aurora and Batavia Wagon Road, Lake Street, Aurora and Batavia Road, State Road (Route 31) and currently, Lincolnway. Several of the lots had previously been sold to the parties whose names appear on the respective lots as shown on the map. This subdivision was first entered on plat a map in 1890.

John F. Schneider sold this corner lot on State Street and Lincolnway to Anna Banbury in June 1890. It was later home to the Flynn, Reid, and Glines families. Today it is unusual to find a residential area in an area where two major intersecting roads are located. Usually these houses hold businesses just as do those to the south of State Street.

This house at 4 Lincolnway sits on lot 2 and has been home to many families over the years. The first recorded owner was Andrew P. Cobb who deeded the land to Samuel Graham in 1893. Later owners were Burg, Erickson, Graham, Flynn, Hallstrom, and Hagerman. The house was built in 1920 when William and Mary Flynn were the owners.

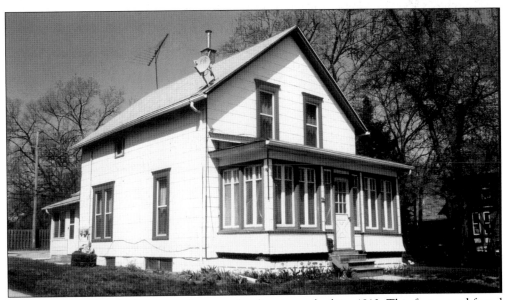

This house probably had an open front porch when it was built in 1910. This first record found was for the sale by Charles Johnson to August Burg in 1891. As with many other houses in North Aurora, the porch has been enclosed for more room and as a barrier to the winter winds.

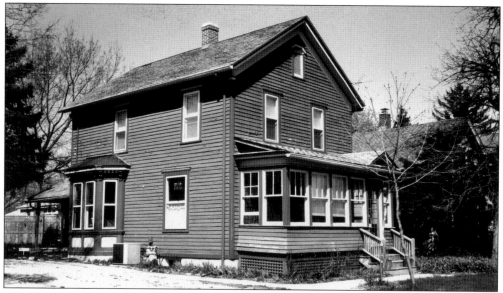

The histories of lots 7, 8, and 9 are intertwined. Schneider first sold lot 9 to Joseph Stewart in 1890. Mat Milchert's sale to Jacob Plain in 1891 was the first recorded for lot 8. The current house, built in 1910, sits on lots 7 and 8 and one foot of lot 9. Notice the bay window, which allows more light into the house.

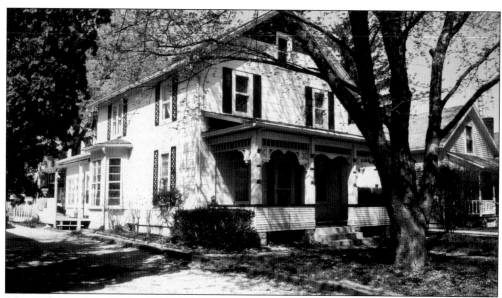

John F. Schneider sold this lot to Henry Flynn in 1890, but again the house was not built until 1910. Look carefully at this house and the two previous ones. The basic houses seem to be the same except for some trim work on this one. The porch has also been left as a porch. Both this house and the one beside it also have bay windows on the south side where the house at 12 North Lincolnway has two windows. The interiors, however, are completely different.

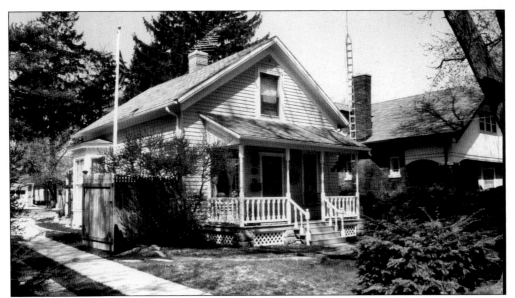

The first recorded sale of this land by Schneider was to David Flynn in 1891, but the house is believed to be much older. The original floor plan showed the entry opening into the living room with a kitchen to the right side. The dining room was just beyond the living room and the bedroom and bath were to the right. One can still see where coal was shoveled through a basement window to the dirt-floored basement.

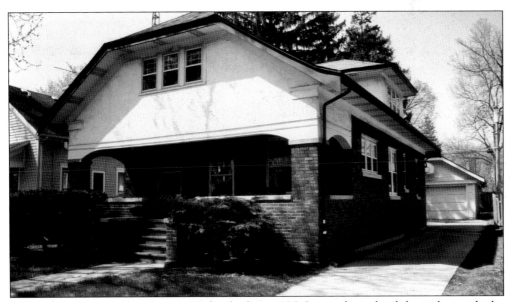

This is a later house that Barney Bricker built in 1925. It is a classic brick bungalow with the low-pitched roof and wide eaves. These one-and-a-half-story houses were usually square and compact and made comfortable family homes.

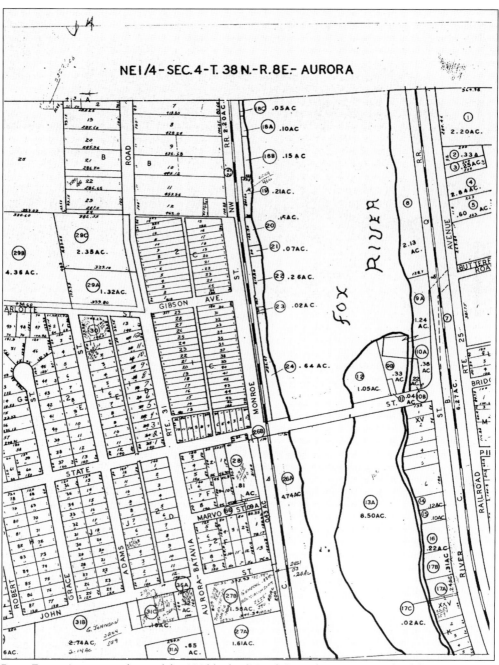

River Forest Acres is made up of the 100 block of North Lincolnway just north of the commercial building and library on the corner of Oak Street and North Lincolnway. It is designated by the letter B on the map. This was one of seven subdivisions that were noted for fixing and designating the corporate limits of the village of North Aurora in an ordinance dated March 26, 1928. This book features houses in two other additions, Nelson's Addition and Winter's Addition. None of the existing houses in River Forest Acres were built before 1940; most look as if they are plans from the 1960s.

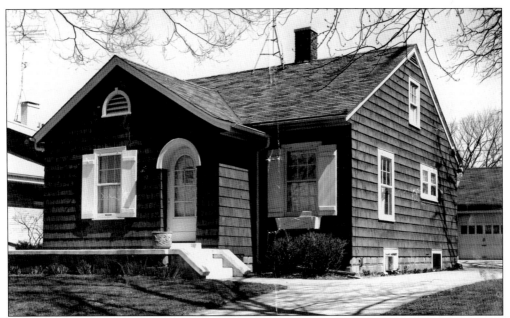

This house at 17 Adams Street was part of the Winter's Addition. Fred Sandell (the youngest of Hannah Sandell's children) used Montgomery Ward plans to build the house. While he was building it, tragedy struck the family. His mother died on the way home from a family reunion in Wisconsin. He and two friends had an automobile accident on the way to retrieve her body. Several of his friends helped complete the house for Fred and his family.

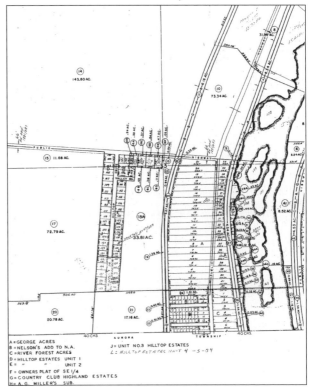

Nelson's Addition was the first subdivision to add streets to the plat. This subdivision began one lot south of Maple Street and continues through two lots north of Elm Street. The streets ran from Lincolnway back to the rail line. Nelson's Addition is designated A on this map.

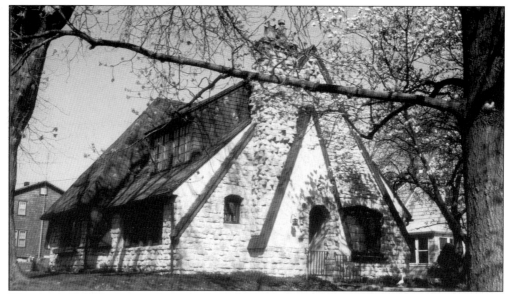

Houses on this block were built in the late 1920s. This one at 200 North Lincolnway was built in 1928 when Mary Simpson was the owner of the lot. Frank Riddle deeded these lots to Alice I. Nelson in 1926 and she sold them over the next few years. Tudor Revival houses with their high-peaked roof lines are perfect for the snowy winters in North Aurora.

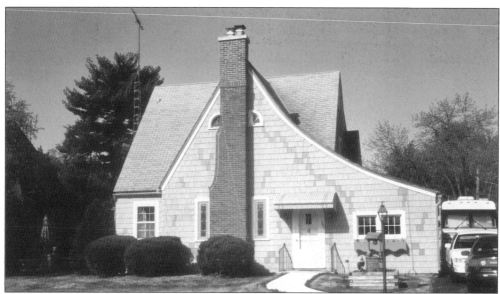

The house at 202 is in the Storybook style that was so popular in the early 1930s, but it was built in 1926. The sloping roof is called a cat slide roof. The high-peaked roof and narrow eves were typical of this style. Many plan books featured houses similar to this one and the two to the north.

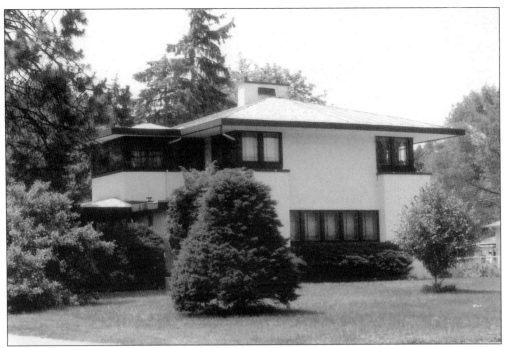

This house was built in 1915 and is an early prairie-style building made popular by Frank Lloyd Wright. It was not included in any subdivision plan submitted to the county. It looks like a scaled back version of the Sears Roebuck house named Aurora.

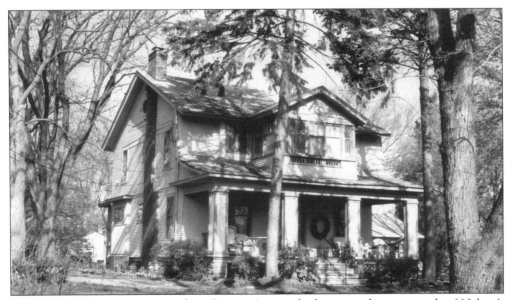

The next subdivision going north is George Acres, which covers the area north of Nelson's Addition to Mooseheart Road. This subdivision is outside the village limits. The house was built before the houses featured in Nelson's Addition. William H. Sperry built this beautifully preserved house in 1912.

# INDEX

Almond, Mrs. Elmer, 72
Anderson family, 25, 108
Angell family, 32, 65
Aurora, Elgin and Chicago Railroad, 54
Aurora Downs Race Track, 76, 77
Aurora Smelting and Refining Company, 16, 60
Backes, Ben, 53
Baldridge family, 112
Banbury family, 65, 118
Barber family, 36, 39, 40, 41–43
Barnum and Bailey Circus, 91
Barrie, E. S., 89
Beatty, Clyde, 92
Belsen Manufacturing Company, 70
Berringer, Helen, 108
Bircher, Miss, 100
Black Hawk, 9
Blasages family, 25
Boardman, Lou, 16
Bohm, Max, 89
Bouckup, Fred, 40
Bricker, Barney, 121
Brown family, 63, 112, 113
Buck family and store, 96
Burg family, 119
Chicago, Burlington and Quincy Railroad, 112
Carlson, Mrs. John, 72

Chicago and Aurora Railroad, 13
Chicago and Northwestern Railroad, 13, 101, 112
Clark, Richard, 100
Cobb, Andrew P., 119
Cole Brothers Circus, 92
Congregational Church, 74, 97
Croushorn family, 25, 30, 53, 117
D. R. Sperry Company, 16, 65–68, 115
Daleiden family, 25, 28, 114
DeKing family, 33
Denham family, 19, 21
Derry, Vernon, 60
Dicke family, 110, 112
Dietrich family, 111
Dornback, Mrs. William, 72
Eichsmann family, 16
Ekstrom, Harold, 108
Erickson family, 25, 105, 108, 119
Evans, Mrs. Charles, 72
Exposition Hotel, 89, 156
Exposition Park, 41, 42, 57, 58, 71, 78–91
Feltes family, 50
Flynn family, 25, 26, 44, 65, 118, 119, 120, 121
48 Insulation Company, 34
Fox family, 80, 94

Fox Garden, 75
Frieders family and businesses, 28, 29, 30, 31, 32–34, 35, 39, 55, 62, 72, 75, 107
Frydendahl (Fredendahl) family, 25, 65
Gannon, Miss, 101
George family, 63, 110, 114, 125
Gibson family, 110
Glines family, 25, 69, 118
Goodwin, 63
Gorham family, 44, 62
Goyette, Charles, 113
Graham family, 70, 82, 83, 84, 108, 119
Grange, "Red," 90
Gray, Raymond, 36
Hagenbeck-Wallace Circus, 91, 92
Hagerman family, 53, 108, 119
Hallstrom family, 119
Hammon family, 72
Hanosh family, 8, 25
Hansen, John, 70
Hartsburg and Hawksley mill, 14, 64, 65, 115
Hartsburg family, 63, 108
Hawksley family, 25, 38, 63, 111
Hettinger family, 25
Hines family, 40, 41

Hopp family, 33, 35

House of David, 90

Howard family, 53

Johnson family, 25, 108, 119

Kansas City Monarchs, 90

Kelleher family, 16, 68

Kies, Mrs. Harry, 72

Kilian family, 24

Kline, Louise, 108

Klingberg family, 44

Koehler, Miss, 108

Komes family, 28

Kramer family, 65

Kurns family, 25, 72

Livingston, Jonathan, 58, 81

Long family, 25, 65

Love Brothers, 16, 60

Lundstrom, Alfred, 65

Lyon's livery stable, 96

Macgruder, Ruth Ekstrom, 108

Mardo, Pete, 91

Masse, Margaret, 108

Massees family, 25

McCoy, E. E., 107

Messenger family, 49, 100

Meyer, Ed, 70

Meyers family, 25

Midwest Brass Foundry, 60

Milchert, Matt, 120

Miller, Dorothy Ann, 65

Monarch Auto Car Company/ Monarch Automobile Company, 61, 117

Morris, John, 96

Moutray family, 116

Murray family, 68

Naper brothers, 11

Nelson family and Nelson's Addition, 26, 27, 44, 114, 122, 123, 124, 125

North Aurora Business Association, 70

North Aurora Creamery, 15, 48, 49, 70

North Aurora Elevator Company, 48, 49, 50, 70

North Aurora Farmers' Cooperative Company, 49, 70

North Aurora Fire Department, 70

North Aurora Hotel, 17, 59

North Aurora Lions, 70

North Aurora Mill, 117

North Aurora Sash, Door and Blind, 63

OO&EBV Railroad, 112

Offutt family, 105

Peck, Perle, 69

Peerless Pennsylvanians, 83

Perry, L. L., 77

Petit, Peter, 15

Plain, Jacob, 120

Plante (Plant) family and blacksmith shop, 15, 25, 49, 53, 54

Plum family, 31, 33, 35, 39, 53, 68, 108

Potawatomi, 10

Pottsolk, Mrs. Ralph, 72

Reid family, 118

Rheutasel, Emma, 46

Richard, J., 77

Riddle, Frank, 124

Rieter, Otto, 65

Ringling Brothers Circus, 91

Rippinger, Jo, 99, 103

River Forest Acres, 122

Robinson, Hazel, 72

Sandell family, 8, 30, 100, 116, 117, 123

Schirtz family and saloon, 25, 53

Schneider family, mill, and Schneider's Addition, 9, 11, 12, 13, 14, 18–23, 25, 31, 32, 37, 38, 45, 46, 49, 63, 73, 74, 93, 95, 96, 110, 113, 115, 118, 120, 121

Schomer, Matt, 65

Schwickert family, 108

Seattle Harmony Kings Orchestra, 83

Shabonna, 10

Simpson, Mary, 124

Slaker (Ochsenschlager) family, 13, 17, 24–26, 27, 36, 45, 78, 93, 95, 101, 102, 103, 109, 110, 111, 113

Smith family and barbershop, 7, 62, 63, 113

Sperry family, 65, 66, 115, 125

Stewart family, 25, 65, 120

Stone family and Stone's Subdivision, 51, 63, 72, 110, 112, 113, 115

Stumbaugh, Harold, 108

Swanson, Vera, 46

Tallman, Grace, 72, 102

Taske family, 65

Tavenner (Tavaner) family, 72, 95, 98

Thalero's Circus, 91

Thielen, Frank, 58, 78, 79, 80, 84, 88

Theis, Nick, 65

Thompson family and Balloon and Parachute Company, 59

Thompson's Barbecue, 69

Thorsen, John, 117

Thurston, A. G., 93

Tiffany, I. M., 63, 113

Tuftee family, 47, 80, 102, 109, 111

Undesser family, 25

Van Fleet family, 44, 69, 96, 110

Vaughn, Elmer, 36

Wade family, 39

Waubonsie, Chief, 10

Weaver, Bart, 101

Wennmacher family, 16

Whelan, Frank, 75

Windett, Florence Croyl, 108

Winter family and Winter's Addition, 20, 32, 45, 95, 122, 123

Worth family, 65, 108

# ACROSS AMERICA, PEOPLE ARE DISCOVERING SOMETHING WONDERFUL. THEIR HERITAGE.

Arcadia Publishing is the leading local history publisher in the United States. With more than 3,000 titles in print and hundreds of new titles released every year, Arcadia has extensive specialized experience chronicling the history of communities and celebrating America's hidden stories, bringing to life the people, places, and events from the past. To discover the history of other communities across the nation, please visit:

## www.arcadiapublishing.com

Customized search tools allow you to find regional history books about the town where you grew up, the cities where your friends and family live, the town where your parents met, or even that retirement spot you've been dreaming about.